Turner

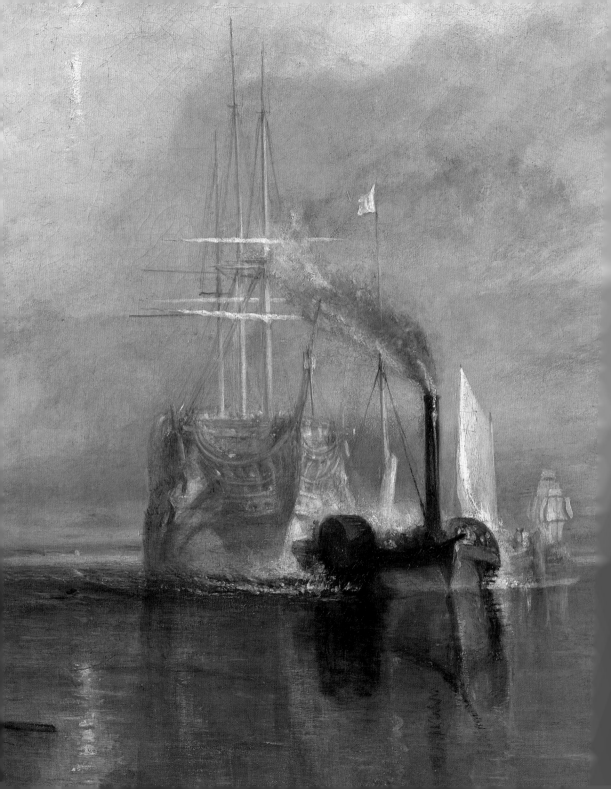

Masters of Art

Turner

Gabriele Crepaldi

PRESTEL

Munich · London · New York

Front cover: *The Dogana, San Giorgio, Citella, from the steps of the Europa*, 1842, Tate Britain, London (detail)
Frontispiece: *The Fighting "Temeraire" Tugged to her Last Berth to be Broken Up*, 1838, National Gallery, London (detail); see page 117
Back cover: *Self-Portrait*, c. 1798–1799, Tate Britain, London (detail); see page 41

© Prestel Verlag, Munich · London · New York, 2011. Reprint 2016
© Mondadori Electa SpA, 2007 (Italian edition)

British Library Cataloguing-in Publication Data: a catalogue record for this book is available from the British Library; Deutsche Nationalbibliothek holds a record of this publication in the Deutsche Nationalbibliografie; detailed bibliographical data can be found under: http://dnb.d-nb.de

The Library of Congress Number: 2011931017

Prestel Verlag, Munich
A member of Verlagsgruppe Random House GmbH

Prestel Verlag
Neumarkter Strasse 28
81673 Munich
Tel. +49(0)89 4136 0
fax +49(0)89 4136 2335
www.prestel.de

Prestel Publishing Ltd.
14–17 Wells Street
London W1T 3PD
Tel. +44 (0)20 7323-5004
Fax +44 (0)20 7323-0271

Prestel Publishing
900 Broadway, Suite 603
New York, NY 10003
Tel. +1 (212) 995-2720
Fax +1 (212) 995-2733

www.prestel.com

Prestel books are available worldwide. Please contact your nearest bookseller or one of the above addresses for information concerning your local distributor.

Editorial direction by Claudia Stäuble, assisted by Franziska Stegmann
Translated from the German by Jane Michael
Copyedited by Chris Murray
Production: Astrid Wedemeyer
Typesetting: Wolfram Söll, designwerk
Cover: Sofarobotnik, Augsburg & Munich
Printing and binding: Elcograf S.p.A., Verona, Italy

Verlagsgruppe Random House FSC® N001967
The FSC®-certified paper *Respecta Satin* is produced by Burgo Group Spa., Italy.

ISBN 978-3-7913-4621-2

Contents

Introduction

Turner's art is unique: a fascinating mixture of steam and water, of light, air and fire, of memories of the classical past and closely observed depictions of contemporary reality, of tradition and challenging innovation. He was truly one of the chosen few: a pupil at the Royal Academy Schools from the tender age of fourteen, he was an outstanding student in all subjects—oil painting, watercolors, drawing, and engraving. An inveterate "Romantic wanderer" keen to discover the world and acquire material for his art, as a young man Turner frequently went on long walking tours through the English and Welsh countryside. And even at this stage his voracious appetite for the real, for recording precisely what he saw, was increasingly colored by his personal vision; for Turner, the heart and the imagination were as important as the eye.

Unlike his great contemporary and rival John Constable, who retained his close links with the English countryside, Turner liked to explore the world and to discover other landscapes in an intensive and deeply English way. He therefore left England several times on extended study tours of the Continent. In 1803 he set out on his first journey through Europe, but instead of taking the classic southern routes of the Grand Tour he chose the snow, mountain lakes and "sublime" peaks of the Alps. His first journey to Italy, in 1819, took him to Venice, where he fell in love with the reflections and the transparency of water, with the stones, the sky and the clouds. Although he admired the luminosity of the skies over Rome and Naples, it was Venice to which he felt emotionally drawn; he would return on four successive trips to gather views that were fundamentally different from those of Canaletto, and which countless British landscape painters would later take as their models.

Turner's way of looking at things was new. His use of color and light, his sharp eye, his dissolving of forms as his view of the world became increasingly dynamic, allowed him to revitalize a largely predictable and unadventurous landscape tradition by creating works of extraordinary originality—works that look forward to the 20th-century Modernism. It was in this way that Turner reached the peak of his maturity: through his outstanding skill in the vivid representation of light filtered and refracted through air and water, of climatic conditions ranging from calm

sunny days to cataclysmic storms, and of scenes of both historic signifi-
cance and everyday life swept up in the vast forces of nature. His irides-
cent colors and free brushwork expressed the irresistible vitality of both
Romanticism and the Industrial Revolution. He sought unique moments
through which he could demonstrate his remarkable talent and his
imagination: blizzards, shipwrecks, storms at sea, conflagrations, the
soft mist of early morning, wild and inaccessible maintain peaks, even
the completely new sight of steam from an engine mixing with the rain,
technology and nature united. In short: Turner is without doubt one of the
most fascinating, independent, and innovative painters in early 19th-cen-
tury Europe, a major figure in art and culture.

In the eyes of his contemporaries Turner's works often appeared alien,
even provocative, and he was subject to sustained criticism—which in
turn led the leading art critic John Ruskin to defend Turner passionately.
And yet, like the other painters of the generation born, and at least partly
educated, at the end of the 18th century, Turner was not a conscious revo-
lutionary: he had no desire to break his ties to the past or reject his
teachers; just the reverse: he wanted to join their ranks. This can be
seen in a telling incident. In 1815, when he was already very famous,
Turner donated to the nation a painting that showed the founding of
Carthage by Dido, on condition that was permanently displayed next to
two famous paintings by Claude Lorrain: a condition which is actually
observed at the National Gallery in London to this day. This story clearly
indicates how Turner's respect for the past was a constant motif and a
fruitful relationship to which he also owed new forms of expression. Just
as current events can be compared with the myths of antiquity, so scien-
tific progress can become the muse of artistic inspiration, and the cur-
rent moment become a myth: a train traveling through the countryside at
top speed enveloped in a cloud of steam and rain can ultimately be wor-
thy to occupy the place previously taken by Agamemnon's chariot before
the walls of Troy.

Stefano Zuffi

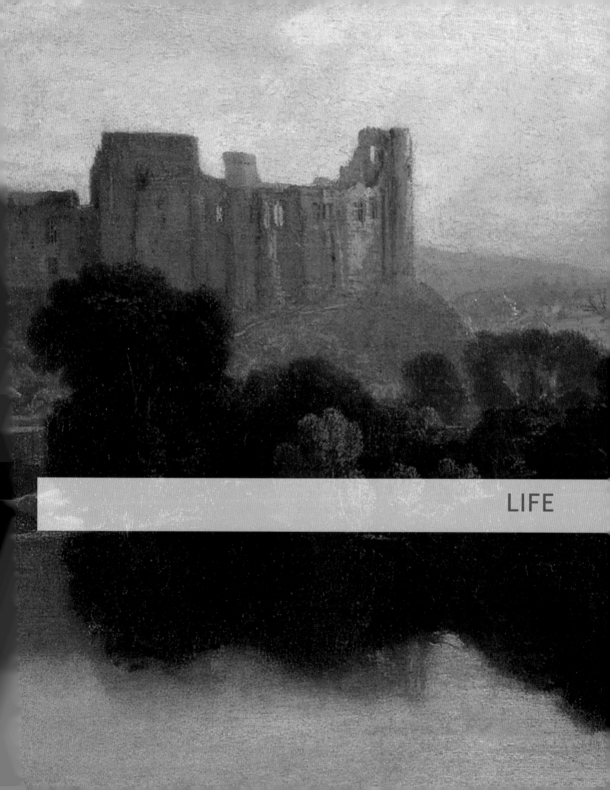

LIFE

From Tradition to Innovation

Turner was a truly enviable artist: a precocious genius who very rapidly gained recognition and for more than sixty years was successful in all genres of landscape painting and in all media; who—despite sustained criticism from the more traditional parts of the art establishment—won a wide range of supporters and buyers, from the landed aristocracy and the newly rich middle classes alike; and who was defended by the finest art critic of the day, John Ruskin. He is now widely seen as one of the greatest artists England has ever produced—and one whose impact is still felt.

Youth (1775–1794)

Joseph Mallord William Turner was born on 23 April 1775 at 21 Maiden Lane in Covent Garden, central London. Though it is generally accepted, there is some doubt as to whether the date is correct, for it looks as if the artist may have decided to use St. George's Day as his birthday—the feast day of the patron saint of England and the (supposed) birthday of William Shakespeare. Turner was the eldest son of William Turner, a barber and wig-maker who was twenty-eight years old when his son was born. His mother, Mary Marshall, was six years older than her husband and suffered from a mental illness that deteriorated markedly after the premature death

of her daughter, Mary Ann, in 1786. In 1800 she was admitted to the Bethlehem Hospital in London, where she died on 15 April 1804. This may be the reason why the young Turner was so often sent to stay with relatives. When he was five years old he probably visited Margate for the first time. At the age of ten he spent some time at the home of a maternal uncle in Brentford in Middlesex. There he was enrolled in John White's school and started to color engravings, his first modest experiment in art. But it was probably his experience of nature during long walks along the banks of the Thames that aroused his enthusiasm for painting, for which he revealed a remarkable talent from the outset. The first signed and dated drawings, mostly copies of engravings, date from the year 1787. In a sketchbook he used around 1789 in Sunningwell near Oxford we find further exercises: studies for landscapes and views of London which show that he already had a good technique and a steady, sure hand.

His father noticed his son's talent, encouraged him, and even began to exhibit his drawings in the window of his shop; he sold them for between one to three shillings. At first the young Turner was the pupil of the architect Thomas Hardwick, who advised him to concentrate on painting, and then (at the Academy) of Thomas

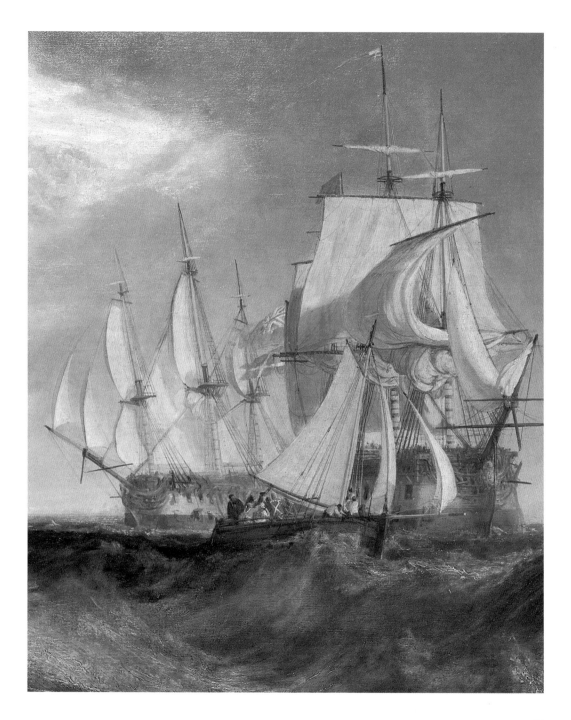

11

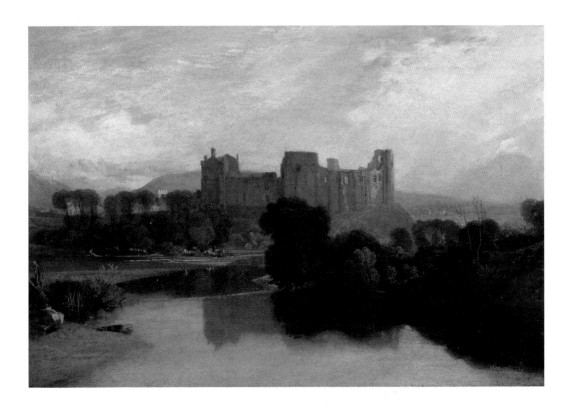

Cockermouth Castle,
1810,
Petworth House,
Sussex

Malton the Younger, who specialized in topographical and architectural views.

On 11 December 1789, having passed his examination with distinction, Turner was awarded a scholarship at the age of only fourteen to the Royal Academy Schools, where he studied until 1793. As early as April 1790, when he had only just turned fifteen, one of his watercolors, *View of the Archbishop's Palace in Lambeth* (Indianapolis Museum of Art), was accepted for the Royal Academy's annual exhibition. The critics' comments were positive, especially in view of Turner's age. They praised in particular the accuracy of his perspective and his use of light. They also noticed a number of stylistic qualities that would have been worthy of a much more experienced artist.

In September 1791 Turner set off on the first of his many journeys in search of landscapes which he could depict in his paintings. He visited Bath, Bristol, Malmesbury, and other locations in Somerset and Wiltshire. During the following year he attended life-drawing classes at the Royal Academy, traveled to central and south Wales in search of further inspiration for his landscapes, and began to produce illustrations for a number of periodicals such as the *Copper Plate Magazine* and the *Pocket Magazine*, which gave him some degree of financial independence.

On 27 March 1793 one of his drawings was awarded the Greater Silver Palette of the Royal Society of Arts. He now earned his living by giving drawing lessons and by selling his watercolors. In May 1794 an engraving of one of his drawings was published: a view of Rochester in the periodical *Copper Plate Magazine*. Turner also took part in the annual exhibition of the Royal Academy for the first time with five watercolors, including *St Anselm's Chapel, Canterbury Cathedral* (The Whitworth Art Gallery,

Manchester), which received positive reviews in the *St. James Chronicle* and the *Morning Post*. The critics began to take notice of him and realized that he was not just a skilled child prodigy but an artist who already possessed not only a remarkable technique and unusual sensitivity but also a distinctive character. From now on Turner regularly took part in the annual exhibitions of the Royal Academy. Between 1794 and 1851, the year of his death, he missed only five of the fifty-eight exhibitions, in total presenting 179 works, of which 108 were sold.

Training (1795–1799)

In 1795 Turner showed eight watercolors in the exhibition of the Royal Academy. In the same year he received commissions for topographical drawings, some of which were to be used for engravings. He therefore spent the months of June and July in south Wales, while in August and September he stayed on the Isle of Wight.

In 1796 he sent ten watercolors and his first oil painting, *Fishermen at Sea* (Tate Britain, London), which was sold for ten pounds, to the Royal Academy exhibition. The engraver Edward Bell described it as "a view of flustered and scurrying fishing-boats in a gale of wind off the Needles [three stack of rock that rise out of the sea near the Isle of Wight, seen in the background of the painting]." The assessments of the critics, including John Williams in the *Critical Guide*, were again positive and underlined the artist's ability to reproduce the effect of the moonlit night, as well as the sailors' efforts to resist the primitive forces of nature expressed in the power of the waves threatening to drive them against the rocks. In the two years which followed Turner extended his travels to Sussex, northern England as far as the Lake District, and then to Kent and Wales, as always

in search of new subjects to record in pencil, watercolors, or oils.

In 1798 the regulations governing the Royal Academy annual exhibition permitted the addition of poems alongside the titles of the works on display. Turner, whose cultural interest extended to many disciplines, was delighted at the prospect of being able to combine painting with poetry and began to exhibit his landscapes accompanied by texts by John Milton, James Thomson and other pre-Romantic poets—even his own verses.

In April 1799 he was contacted by Lord Elgin regarding a journey to Athens, his task being to make topographical drawings. Turner, however, allowed himself the luxury of turning down this prestigious commission, since in his view the remuneration offered appeared too low. In fact, enquiries from collectors had increased considerably, and in the first months of the year he had received orders for no fewer than sixty watercolors, for which he succeeded in negotiating increasingly high fees. On 4 November 1799, at the age of only twenty-four, he became an Associate Member of the Royal Academy—an official confirmation of the esteem and admiration in which he was already held.

Journey to Switzerland

In 1800 Turner participated in the Royal Academy's annual exhibition with six watercolors and two oil paintings, including *The Fifth Plague of Egypt*, which proved very successful. During the summer he visited Fonthill in Wiltshire as the guest of William Beckford and painted *Dutch Boats in a Gale (The Bridgewater Sea Piece)*, commissioned by Francis Egerton, Duke of Bridgewater, as a companion piece to *A Rising Gale* (c. 1672, Toledo Museum of Art) by Willem van de Velde the Younger. Turner received the sum of 250 guineas in payment. (In 1976 the painting was sold to a private collector at an auction at Christie's in London for £340,000.) In July and August 1801 Turner went on an extended trip to Scotland. During his return journey he spent a few days in Chester.

On 12 February 1802, when Turner was not yet twenty-seven years old, he was nominated as a Full Member of the Royal Academy. His diploma work, which is still held in the Royal Academy, was the canvas *Dolbadern Castle in North Wales*. Beside the picture hung some verses about the impenetrable silence of the wild Welsh mountains (a popular theme at the time) and the imprisonment of Prince Owain Goch, the prince who between 1254 and 1277 was incarcerated in the castle of his brother, Llewelyn, and freed only after the Treaty of Conway (Conwy), which officially confirmed the conquest of Wales by Edward I of England.

Taking advantage of the Peace of Amiens between Britain and Napoleonic France, in 1802 Turner was finally able to travel abroad for the first time. He left London on 14 July in the company of Newbey Lowson, a landowner, a collector of Turner's paintings, and himself an amateur painter, who paid the costs of the journey. They stopped briefly in Paris and then traveled on to Lyon, where they spent a few days in order to visit the monastery of Grande Chartreuse. Then they continued through the Val d'Isère and after a short stay in Geneva arrived at Chamonix in order to see Mont Blanc, which greatly impressed both men. Since they were unable to cross the massif they had to make a long detour: having passed through the Col du Bonhomme and the Col de la Seigne, they stayed first in Courmayeur and then in Aosta. At this point Turner would have liked to continue to Italy,

but the Peace of Amiens seemed fragile and in order to avoid finding themselves on enemy soil the two Englishmen crossed the Great St. Bernard Pass back into Switzerland, where their guides showed them the places where a few years previously Napoleon, the "new Hannibal," had led his troops.

During the following weeks Turner crossed the whole of Switzerland on foot or on the back of a mule, visiting Martigny, Lausanne, Bern, the mountains of the Bernese Oberland, the St. Gotthard Pass, and finally Zurich and the Rhine Falls at Schaffhausen. From there he returned home, arriving in London on 30 September after a lengthy stay in Paris in order to study the masterpieces in the Louvre and to visit the studios of Jacques-Louis David and Pierre-Narcisse Guérin.

Back at home, he sorted out the many studies and drawings he had made during his journey, some of which he incorporated into his major works, such as *Snow Storm, Hannibal and his Army Crossing the Alps* and *The Fall of an Avalanche in the Grisons*, which can now be seen in Tate Britain in London.

Further success and first critical reviews (1803–1804)

In 1803 Turner began to play an increasingly important role within the Royal Academy, as a member of both the Council and also the committee that selected the works to be included in the annual exhibition. In May of that year he exhibited two watercolors and five oil paintings, including *The Festival Upon the Opening of the Vintage at Mâcon* (Sheffield Galleries and Museums Trust), which was received with mixed reviews. The painting, which shows the River Saône between Chalon and Mâcon, is based on drawings Turner had made in July 1802 on

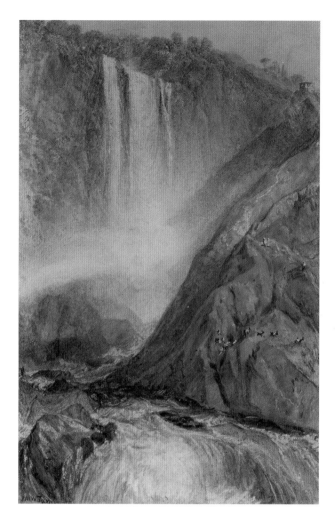

The Falls of Terni, 1817, Blackburn Museum and Art Gallery, Lancashire

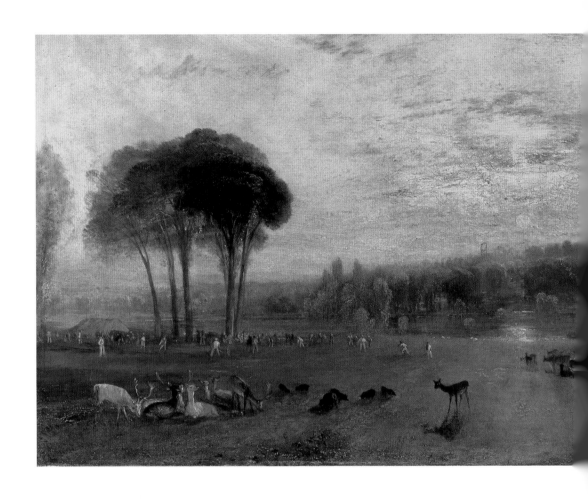

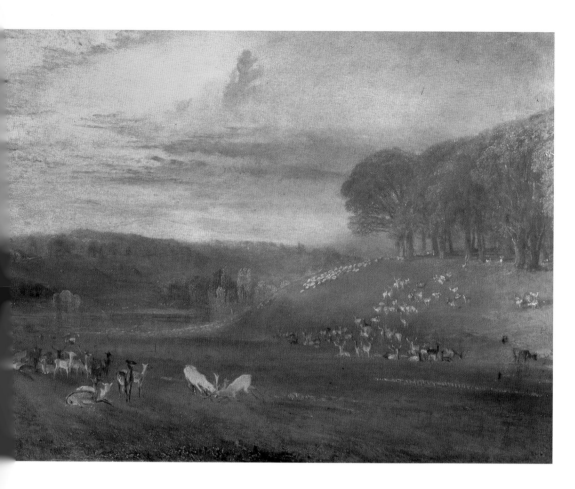

*The Lake, Petworth:
sunset, fighting bucks,
1829,
Petworth House,
Sussex*

17

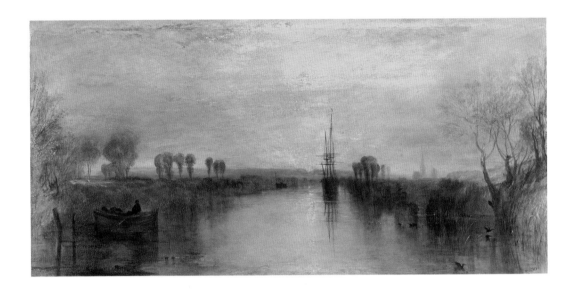

Chichester Canal,
1829,
Petworth House,
Sussex

his way from Paris to Lyon. Swiss-born British artist Henry Fuseli (Johann Heinrich Füssli) praised it, and in a long in-depth article published on 6 May 1803 in *The British Press* John Britton wrote: "It is the first landscape of this kind which has been produced since the time of Claude, whose works Mr. Turner must have studied very carefully and profitably, and we dare to claim that he has surpassed that master in the variety and forms of some parts of his paintings." Very different, on the other hand, was the impression of the critic of the *True Briton*, who in a review which appeared on 16 May 1803 recognized "the stately dignity of the entire design," but accused Turner of "unrealistic magnificence." More important was the criticism expressed by Sir George Beaumont—at the time the final instance in questions relating to culture and art—and other celebrated authorities: they accused Turner of failing to capture the landscape details, of lacking respect for traditional rules, and of taking too casual an approach to drawing and color.

This was just the beginning of a conflict between tradition and innovation, acceptance of the rules and artistic freedom, the imitation of the British masters of the past and personal inspiration, which would eventually lead Turner—after countless exhausting disputes with the British academic world—to the point where he became the symbol of the new Romantic art throughout Europe. At the end of that same year Turner began to work on setting up a private gallery in his London studio, at 64 Harley Street, which opened on 18 April 1804 with an exhibition including about thirty works inspired by his journey to Switzerland. Although he would continue to take part in the annual exhibitions at the Royal Academy, Turner now finally had a place where he could receive the clients who had

commissioned his increasing number of works—where he could show and discuss his latest paintings and, avoiding all forms of mediation, reach agreements with them regarding the sale of his paintings, drawings, watercolors, and prints.

Teaching at the Royal Academy of Arts (1805–1811)

In 1805 Turner painted *The Shipwreck* (Tate Britain, London), which the Baronet Sir John Leicester purchased for £315. It was the first of Turner's oil paintings from which an engraving was produced; executed in 1806, it was printed the following year. In February 1806 Turner presented two oil paintings in the first exhibition of the British Institution. One of them, *The Goddess of Discord Choosing the Apple of Contention in the Garden of the Hesperides* (Tate Britain, London), depicts a subject Turner also treated in a poem entitled *Ode to Discord*. At the end of the summer he stayed at Knockholt in Kent as the guest of William Frederick Wells, who suggested that Turner keep a *Liber Studiorum*, a kind of catalogue of his painting, illustrated with his engravings, in order to make his works more widely known and to explain their meaning. It was to contain one hundred engravings, but this figure was never reached. In October 1806 Turner bought a house in the West End at 6 Upper Mall, Hammersmith, London. On 11 June 1807 the first volume of the *Liber Studiorum* was published.

On 2 November of the same year, Turner was elected to serve as Professor of Perspective at the Royal Academy. He was very proud of the chair and held it until 1828 almost continuously. In order to prepare his classes he read a whole series of books on art theory and aesthetics, these theoretical

studies allowing him to expand and deepen the themes and technique of his own paintings. From then onward Turner adopted the custom of putting the initials P.P. (Professor of Perspective) after his name, as well as R.A. (Royal Academician).

In May 1808 Turner showed a single oil painting in the Royal Academy's annual exhibition: *The Unpaid Bill, or The Dentist Reproving his Son's Prodigality* (private collection), which Richard Payne Knight commissioned him to paint as a companion piece to a Rembrandt he owned. Between 1808 and 1810 he made several journeys to Petworth House in Sussex to stay with his friend and patron Lord Egremont, to Tabley House in Cheshire as the guest of Sir John Leicester, and to Farnley Hall in Yorkshire to visit Walter Fawkes, whom he thereafter visited almost every year until 1824. In December 1810 Turner moved yet again: to 47 Queen Ann Street West. From 1811, at the request of William Bernard Cooke, he undertook various excursions to the south coast in search of interesting subjects which he recorded in numerous watercolors from which engravings were to be made.

Years of intensive work (1812–1816)

1812 began with the perspective classes Turner gave during January and February. In the annual exhibition of the Royal Academy, where he had since become a member of the Council, he showed four oil paintings, including *Snow Storm, Hannibal and his Army Crossing the Alps* (Tate Britain, London). For the first time he presented the painting accompanied by some verses which were taken from his unfinished epic *Fallacies of Hope*. Public and critics alike appreciated the way Turner had depicted the power of the snowstorm, admired the intense dramatic power of the composition,

and understood clearly the implicit references to the continued war between France and Britain, with Hannibal being seen as Napoleon Bonaparte. During the summer construction began on Turner's country house, for which he had drawn the sketches. Planned as a residence for the artist and his father, the house was located in Twickenham, in West London; it was initially called "Solus Lodge" and subsequently "Sandycombe Lodge."

In November and December Turner was once again the guest of Walter Fawkes in Farnley, where he suffered, however, from poor digestion and bad nerves. In 1813 he exhibited two paintings at the Royal Academy; one of them was *Frosty Morning*, which he presented alongside a poem about hoar frost taken from the "Seasons" by the Scottish poet James Thomson. In this case, too, the critics praised the way he had reproduced the atmosphere of the winter morning by means of delicate light effects and simple, sure drawing. They also noticed autobiographical elements, such as the portrayal of girls presumed to be his daughters, and even of his horse, Crop-ear.

During that summer Turner went on an extended journey to Devon in the company of fellow artists Cyrus Redding, Ambrose B. Johns, and Charles Lock Eastlake. He produced a large number of drawings and watercolors (some of which are now in the British Museum, London), which he used during the following months for a series of engravings to which he gave the title *Picturesque Views on the Southern Coast of England*, published the following year. In 1814 he was one of the main founders of an "Artists' General Benevolent Institution," an artists' association in which he served as Treasurer and President of the Administrative Committee. Between 1816 and 1818 he worked on a commission to illustrate a volume of the *History of Richmondshire* by Thomas Dunham Whitaker.

The indefatigable traveler (1817–1821)

Following the end of the Napoleonic Wars and the peace between France and Britain, Turner had the opportunity to travel to Europe again. On 1 August 1817 he left London and traveled through Belgium, his main objective being to see for himself the battlefield of Waterloo, where the decisive encounter between the armies led by Napoleon and Wellington had taken place. He executed a number of sketches in the sketchbook *Waterloo and Rhine*, including a watercolor that Walter Fawkes purchased (1817, *The Field of Waterloo*, Fitzwilliam Museum, Cambridge), and an oil painting that was exhibited at the Royal Academy in 1818 (*The Field of Waterloo*, Tate Britain). The work earned sincere and genuine praise as well as harsh criticism: on 1 June 1818 the critic at the *Repository of Art* emphasized the "tremendous power of the abstraction in the application of the vast areas of color," while the critic on the *Annals of the Fine Arts* described the picture as representing a "drunken hubbub on illumination night." After visiting Belgium, Turner traveled along the Rhine Valley between Cologne and Mainz, where he executed a series of fifty-one watercolors with river views all purchased by Walter Fawkes for a total of £500. Turner finished his journey in Holland, where he was able to study the works of Rembrandt before returning home in September.

In 1818 Turner devoted himself primarily to his activities as an illustrator: during the early months of the year he was commissioned to produce watercolors of Italian subjects based on drawings by James Hakewill and intended for a publication entitled *Picturesque Tour of Italy*.

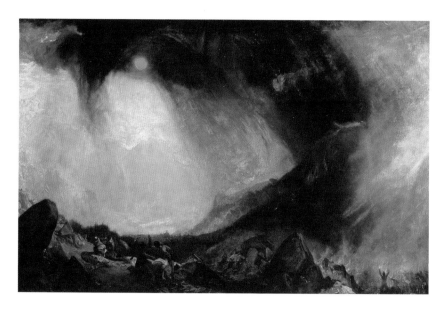

Snow Storm, Hannibal and his Army Crossing the Alps,
1812,
Tate Britain, London

Between October and November Turner traveled to Edinburgh to produce the illustrations for the *Provincial Antiquities* by Sir Walter Scott. In 1819 he intensified his activities and took part in numerous public exhibitions—for example, at the London gallery of Sir John Leicester and at an exhibition in the house of Walter Fawkes, in which he presented more than sixty watercolors. At the end of the year he began the considerable work involved in renovating and extending his house in Queen Anne Street, which was completed two years later with the opening of new, enlarged exhibition rooms.

In August 1819 Turner traveled to Italy for the first time, returning in February 1820. Even before this he had produced Italian landscapes based on drawings, engravings, and paintings by other artists, especially Claude Lorrain, who had often painted Italian views. When he was finally able to visit the places himself, Turner was deeply impressed. He was particularly taken by the dazzling, almost blinding, strength of the sun, which was so very different from the one he was used to in Britain; many critics see this experience as fundamental for Turner's transformation from youth to full maturity as an artist. He arrived in Italy via the Moncenisio Pass and visited the cities of Turin, Milan, and Como, where he was especially moved by the beauty of the lake. He also traveled to Verona and Venice, where he stayed at the Hotel Leon Bianco from 8 to 13 of September. Thanks to the engravings by Antonio Visentini in particular, which, based on the famous paintings by Canaletto, were published between 1735 and 1742, he already had an impression of the City on the Lagoon. Turner was also influenced by works

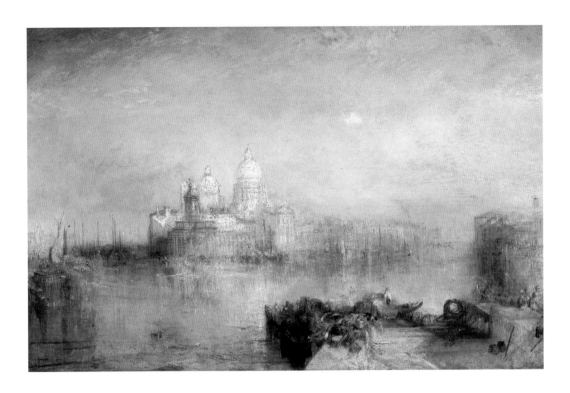

The Dogana and Santa
Maria della Salute,
Venice, 1843,
National Gallery of Art,
Washington

of literature set in Venice, such as *The Merchant of Venice* and *Othello* by William Shakespeare, but even more so by the verse narratives of Lord Byron, especially *Childe Harold's Pilgrimage* (1812–1818).

The watercolors in the sketchbook *Como and Venice* show a new use of light: much warmer, more intense and hazy thanks to the fine, almost transparent dots of color that suggest the brightness and extraordinary clarity of the Italian sky and the freshness of his carefree days of travel. He gradually enriched and expanded his palette of colors, previously limited to just a few, and thus began to move toward the new theories of color developed by Johann Wolfgang von Goethe and others who were carrying out research into optics; such color theories would later fascinate the Impressionists and Pointillists. The next stages of Turner's journey took him to Florence and Rome, where he was elected as an honorary member of the Accademia di San Luca. He established contact with members of the Nazarenes, a group of German artists living in Italy, and also met Antonio Canova, the great neo-classical sculptor. Then he visited Naples in October and witnessed an eruption of Vesuvius—a subject which particularly attracted him and which he had already addressed a few years earlier in a watercolor which his friend and patron Walter Fawkes had asked him to paint (*Mount Vesuvius in Eruption*, 1817), now in the Yale Center for British Art in New Haven. During this time he also traveled to Sorrento and went as far south as Paestum.

On his return to London he had more than nineteen sketchbooks containing over 2,000 drawings in his luggage. The first large painting he produced in that year, *Rome from the Vatican. Raffaelle Accompanied by La Fornarina, Preparing his Pictures for the Decoration of the Loggia* (Tate Britain, London), recalled the 300th anniversary of the great Renaissance artist from Urbino and summarized how much Turner had learned in Italy.

In the following year he made another journey to France and Holland, with long stays in Paris, where he produced a large number of drawings after paintings by Claude Lorrain in the Louvre and also in Rouen and Dieppe.

Ambitious plans (1822–1827)

In 1822 Turner showed seventeen watercolors in the exhibition organized by the publisher William Bernard Cooke from February to August in Soho Square in London. In August he traveled by boat to Edinburgh in order to take part in the official visit of King George IV, who the following year commissioned from him a large painting for St. James's Palace in London, *The Battle of Trafalgar*. The work was subject to virulent attacks by critics, who accused him of numerous mistakes in the details of the ships and who condemned him for his "exaggerated" shades of red. The King therefore decided not to keep the painting in his palace but gave it to the National Maritime Museum in Greenwich, where it hangs to this day. He also commissioned no further works from Turner.

In 1823 Turner presented eleven watercolors at Cooke's and another fifteen the following year before setting off on another long journey which took him initially to the south-east coast of England and then to Belgium, Luxembourg, Germany, and northern France. One of the most important cultural events of the year was the inauguration of the National Gallery in London, which was opened to the public on 10 May 1824. The original core collection of works the museum held at that point consisted of the paintings Parliament had purchased from Sir George Beaumont and

John Julius Angerstein, a rich businessman. Turner was invited to join the board, and it is likely that it was on this occasion that he had the idea of leaving works to the nation in his will. During November and December he was a guest of Walter Fawkes at Farnley for the last time; Fawkes died on 25 October of the following year. In 1825 Turner visited Holland, the Rhineland, and Belgium. During the following year he traveled to Brittany and to the valleys of the Meuse, Moselle, and Loire between August and November, returning home, as usual, with numerous drawings.

In 1826 Turner began to produce illustrations for Samuel Rogers' long poem *Italy*. During the following year he and his friend, the architect John Nash, stayed at East Cowes Castle on the Isle of Wight from July to September. In spite of the considerable difference in their ages (Turner was more than forty-four years younger than Nash) the two men shared a genuine and deep friendship. Turner then went on to Petworth as the guest of Lord Egremont. Until the death of the Earl on 11 November 1837, the latter's residence served as a retreat for Turner, where he could select drawings he had brought back from his journeys and prepare the oil paintings he planned to present at the Royal Academy.

During these years the artist received numerous commissions for watercolors which were to serve as models for series of engravings, but not all these ambitious projects were completed. In 1823, for example, he produced *A Storm* (British Museum, London), a coastal view that was planned for a collection of engravings entitled *Sea Views*. In 1825 he painted the watercolor *Prudhoe Castle*, intended for the series *Picturesque Views in England and Wales*. Many engravings for this were prepared and published, the first part in March 1827, but the entire project, which was to include hundreds of pictures, was abandoned in 1838 because of lack of funds. Similarly, watercolors intended for a series devoted to the ports of England was abandoned following a dispute with the engraver Thomas Lupton.

Second journey to Italy (1828–1831)

During the early months of 1828 Turner gave his last classes on perspective at the Royal Academy. Between August and February of the following year he went on his second journey to Italy. He stopped en route in Paris, Lyon, Avignon, and Florence. His main goal was Rome, where he spent three months at 12 Piazza Magnanelli, the house of the young artist Charles Eastlake, who was later the Director of the National Gallery, from 1854 until his death in 1865. As Eastlake himself recorded in a letter written in February 1828, Turner worked feverishly and with great intensity: "... he worked literally day and night here, began eight or ten pictures and finished and exhibited three, all in about two months or a little more. More than a thousand persons went to see his works when exhibited, so you may imagine how astonished, enraged or delighted the different schools of artists were, at seeing things with methods so new, so daring, and excellences so unequivocal."

On 18 December 1828 an exhibition of Turner's works opened in the salons of the Palazzo Trulli in the Via del Quirinale in Rome. Among the paintings shown were *View of Orvieto, Painted in Rome*, *Regulus*, and *Vision of Medea*, all of which today are in Tate Britain. As usual, both the public and critics were divided, with reactions that ranged from keen enthusiasm to repulsion.

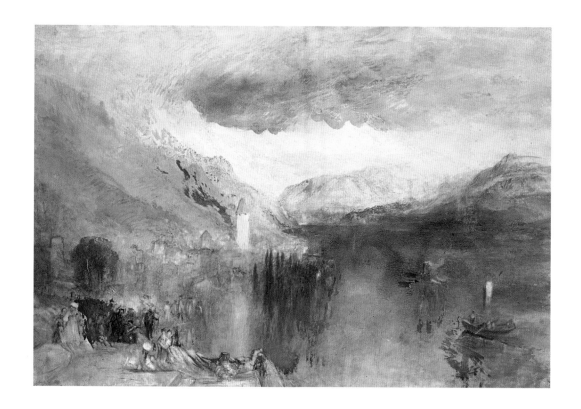

In his memoirs, *Recollections of a Long Life* (1865), Lord Broughton refers to the verdict of the sculptor Thomas Campbell, according to whom Turner's *Vision of Medea* was a "glaring, extravagant daub, which might be mistaken for a joke—and a bad joke too." The remarkable intensity of Turner's use of light and color prompted exceptionally strong reactions; in fact it proved that the artist had finally matured beyond the inspiration of his youthful years, namely the Old Masters, to arrive at a uniquely individual style. In an article on *Regulus* in the *Spectator* on 11 February 1837, the author came to the conclusion that "Turner is the precise opposite of Claude: instead of harmony, beauty, sweet merriment and the warm light of the Italian landscape, everything here is all dazzling light, excitement and restlessness. The only way to reconcile oneself to the painting is to look at it from a great distance, for then one will see nothing except an explosion of sunlight. It is a stage backdrop and exquisitely beautiful in its own way." Evidence of his having distanced himself from the approach of the Old Masters can also be found in the large oil painting *Palestrina* (Tate Britain, London), which was executed between the end of 1828 and January of the following year in

Oberhofen, Lake Thun, 1848, Indianapolis Museum of Art, Indianapolis

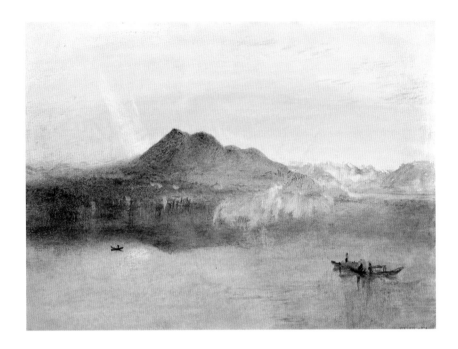

The Rigi: Sunrise.
Study for the Dark
Rigi, 1841,
Tate Britain,
London

Rome at the express request of Lord Egremont, who wished for a companion piece to Claude Lorrain's *Landscape with Jacob and Laban and his Daughters* (1676, Dulwich Picture Gallery), which was also in his possession. In spite of their long friendship the British aristocrat realized that Turner's painting was far too different from that of Claude Lorrain, and somewhat reluctantly did not purchase it.

In February 1829 Turner returned to London via Loreto, Ancona, Bologna, Turin, Moncenisio, and Lyon. During the months of June and July 1829 the publisher Charles Heath showed forty of Turner's watercolors in the Egyptian Hall in Piccadilly in London, including some which had been produced for the *Picturesque*

Views of England and Wales. In July Turner returned to France, visiting Paris, Normandy, and Brittany. His father died on 21 September. He had been the first to recognize and admire Turner's talent and the relationship with his son had been a very close one since the death of his wife in Bethlehem Hospital. In a sense he had served as his son's assistant when the latter was painting.

July 1830 saw the publication of Samuel Rogers' volume *Italy* containing Turner's illustrations. In August and September Turner traveled to the Midlands yet again. In February 1831 he went to Edinburgh at the invitation of Robert Cadell, Sir Walter Scott's publisher, in order to illustrate the poems of the great Romantic writer; he

met Scott at the writer's home, Abbotsford House, near Melrose.

Maturity (1832–1837)

In September 1832 Turner visited Paris, where he produced several views of the Seine and collected material to enable him to illustrate *The Life of Napoleon Bonaparte* by Sir Walter Scott, and where he admired the paintings by Eugène Delacroix, whom he most probably met. During the following years he continued to travel tirelessly in Germany, Austria, France, Denmark, and Switzerland, either to visit museums and art collections or in search of landscapes he had not previously seen. In September 1833 he spent a week in Venice in the Hotel Europa in the Ca' Giustinian in San Marco. In 1834 he illustrated Samuel Rogers' *Poems*. Between 1833 and 1835 he published *Turner's Annual Tour*, a series of city views and landscapes from a wide variety of locations, and from 1833 to 1836 his series of engravings *Landscape Illustrations to the Bible*.

Turner continued to maintain a strong interest in Romantic literature, as can be seen in the illustrations for the works of Sir Walter Scott, which he successfully exhibited at the Moon Gallery, at Boys & Graves, and at Byron's Gallery. He had long reached full maturity as an artist, and despite his sometimes turbulent relationship with the critics he could feel that he was admired and honored as a recognized and respected painter, with enough collectors to permit a life of considerable prosperity.

It was during the next phase of his career that he created many of his most famous works, those in which he finally emancipated himself from the realistic depiction of a landscape in order to pursue a new and fascinating style, based on an imaginative and evocative view which transcends the world of real appearance and moves on to a purely spiritual plane. It was these works that would fascinate 20th-century artists.

Last journeys (1838–1845)

In 1838 Turner, who had finally retired from his teaching post at the Royal Academy, continued to paint and to attend to his customers at his London gallery while spending his free time at Margate in Kent. The following year he showed forty watercolors in the Music Hall in Leeds and traveled to the regions around the Meuse and the Moselle and to Luxembourg. From 20 August until 3 September 1840 he was embarked on his third trip to Venice, where he stayed once again at the Hotel Europa. On the outward journey he stopped in Rotterdam and near the Rhine Valley; on the return trip he visited Munich and Coburg.

During the following two years he traveled more than once to Switzerland and on each occasion stayed for a few days in Lucerne, Zurich, and by Lake Constance. Unlike on his previous journeys, he was now less interested in views of the towns, focusing mostly on views of nature. In the winter he presented the watercolor studies he had made in Switzerland to the art dealer Thomas Griffith, so that the latter could show them to his customers in order to give them an opportunity to select a sketch from which the artist would then produce an oil painting. Turner proposed a total of fifteen new subjects, four of which had been worked out in detail, and he succeeded in acquiring nine orders from three customers.

Between 1843 and 1845 Turner undertook further journeys to Switzerland, the Tyrol, France, and Italy, but his health began to deteriorate and it became increasingly hard for him to paint. In 1845 he sent

The Plym Estuary from Boringdon Park, 1813, Tate Britain London

a painting entitled *The Opening of the Wallhalla* (Tate Britain, London) to the European Congress of Art in Munich, but the work was poorly received and Turner suffered further when one of the authors of a new encyclopedia of artists described him as a "dauber."

On 14 July of the same year, in his capacity as the oldest member of the Royal Academy, he took over the coveted post of President, standing in for Sir Martin Archer Shee, who was unwell. During the following September and October Turner went on his last journey abroad, to Dieppe and along the coast of Picardy.

All is light (1846–1851)

At the beginning of the 1840s Turner both studied and put into practice the *Theory of Colors* (*Zür Farbenlehre*, 1810) by Johann Wolfgang von Goethe. Charles Lock Eastlake had translated the text into English for him, so that Turner had the opportunity to study it in depth and write his own comments on it.

Goethe saw light as the principle governing the world, since the nature of things is revealed through color. Color is therefore the ultimate expression, that is to say the very soul, of the world, a proposition supported by Arthur Schopenhauer in his essay *On Vision and Colors* (*Über das Sehn und die Farben*) of 1816. Turner had already come to a similar conclusion. In his last works, color dominates the picture space and thus gives powerful expression to his Romantic approach to nature. Goethe's ideas encouraged him to continue to pursue the path he had chosen. He ignored the criticism which was voiced in various

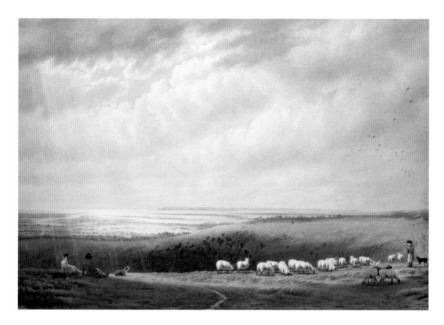

quarters regarding his style, which was considered to be far too free and unconstrained.

Turner produced numerous sunrises and sunsets in which the colors of the sun's rays are depicted in a seemingly endless range of shades. In his paintings of water, which he described as the "flowing, ephemeral reflection," he achieved an even greater degree of subtlety. Beside the Swiss and Italian lakes, beside British rivers and seashores, he described with extraordinary skill the calm or agitation of the natural elements and myriad bright reflections and refractions of light falling on water, which is sometimes still, sometimes flowing, eddying or lifted in waves, and sometimes swept into the air in a storm. In order to find a similar use of light and color it is necessary to look to Claude Monet's *Impression: Sunrise* (1872) or his magnificent series of *Water Lilies*, which the leading Impressionist created in the early years of the 20th century.

In 1846 Turner purchased a little villa in Davis Place at 119 Cremorne New Road (now Cheyne Walk) in Chelsea, where he spent the last years of his retiring but still artistically active life. He gradually reduced his public appearances but never stopped painting and showing his works in the annual exhibitions of the Royal Academy.

Joseph Mallord William Turner died on 19 December 1851 at the age of seventy-six. His body was laid out in his studio until 30 December to give his fellow-artists and collectors an opportunity to pay their last respects. He was buried with full honors in St. Paul's Cathedral in London, next to Sir Joshua Reynolds.

WORKS

View of Tivoli with the Temple of the Sibyl and the Cascades

1796

Watercolor and graphite on paper, 41.8 x 54.9 cm
Paul Mellon Collection, Yale Center for British Art, New Haven

The waterfalls and ruins at Tivoli not far from Rome are subjects that occur frequently in 18th-century painting. They became symbols of the particular feeling for nature that permeated many landscapes of the period and that influenced the works of the youthful Turner. The young aristocrats who traveled to Italy following the routes of the Grand Tour sought out not only the famous cities with their rich heritage of history and art, but also natural settings, particularly those enhanced by ruins to form a contrast between nature and civilization. Returning home, they asked artists to create works which would reawaken their memories of those atmospheric and evocative locations. This led to the aesthetic category known as the "picturesque," recognizable in the classical, Arcadian views of Claude Lorrain and finding its strongest echoes in the Romanticism of John Constable and Turner. Among the many artists who were enchanted by the waterfalls of the little town in Latium, Honoré Fragonard stands out in particular: in 1752 he won the annual Prix de Rome competition, stayed in the Villa d'Este in Tivoli for three months as a guest of the Abbé Richard de Saint Non, and there produced countless drawings and paintings, one of which (*Cascades as Tivoli*) can be found today in the Louvre in Paris. No less famous is the *Villa of Maecenas in Tivoli* (1776–1781, Victoria and Albert Museum, London) by John "Warwick" Smith, one of the most famous British watercolorists of the period. Other equally celebrated examples are paintings by Robert Hubert (*The Falls of Tivoli*, 1768, Musée des Beaux Arts, Pau), Jacob Philipp Hackert (*The Waterfalls of Tivoli*, 1785, Hamburger Kunsthalle), Claude Joseph Vernet (*The Tivoli Cascades*, 1740–1748, Le Petit Palais, Paris), and Johann Melchior Roos (*Cascade of Tivoli*, Musée des Beaux-Arts, Valenciennes).

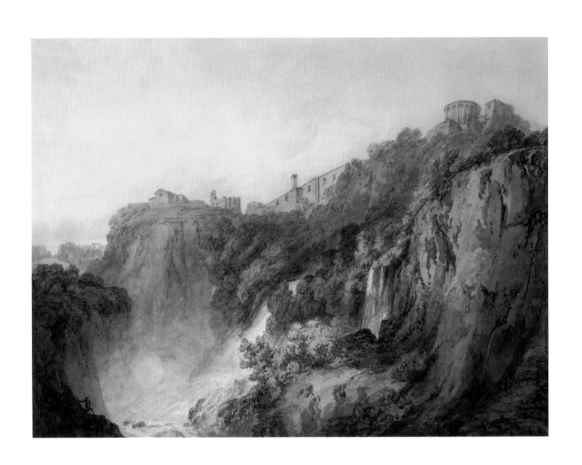

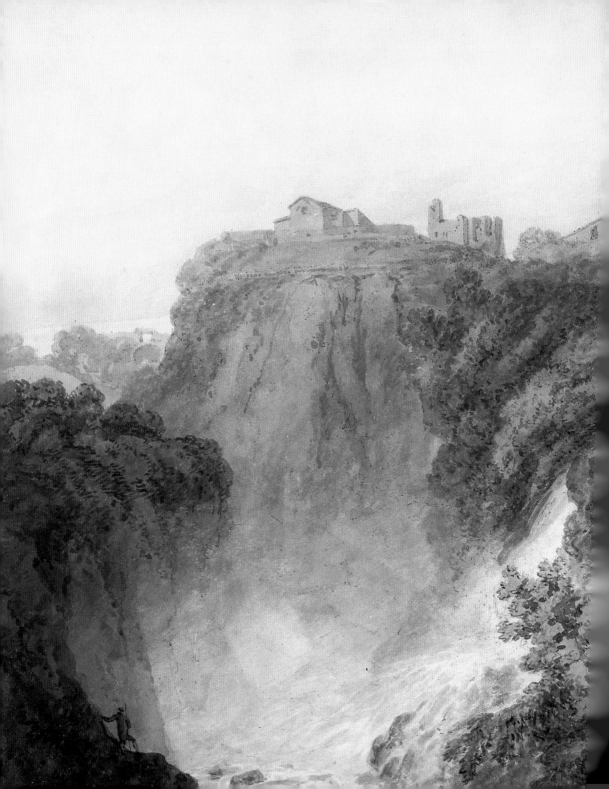

North-East View of Grantham Church, Lincolnshire

1797

Watercolor and graphite on paper, 13 x 17.6 cm
Paul Mellon Collection, Yale Center for British Art, New Haven

This early watercolor by Turner shows the influence of Thomas Malton the Younger, who, as a specialist in architectural and topographical subjects, was Turner's teacher at the Royal Academy. In the last three years of the 18th century, the young student applied himself with energy and total dedication to his studies in both theory and practice, driven by a fixed goal and an unswerving faith in his own talent. In this composition we can recognize a conscientious care with regard to architectural details, a precision and sureness in the drawing, and an attentive use of shading that gives the scene the right depth and also achieves a harmonious relationship between the massive building and the sky which forms the background, which is largely covered with clouds. The horizontal thrust of the solid, massive structure of the church is balanced by the upward movement of the pointed windows and above all by the tall, slender spire, which with a height of 282 feet (86 meters) is one of the tallest church spires in England. The figures in the foreground were added both to emphasize the size and grandeur of the building and also to lend the scene an air of everyday tranquility.

Dedicated to St. Wulfram, the church was built during the early 14th century on the spot where once a Saxon church had stood. Over the course of the centuries it was extended and rebuilt on a number of occasions, especially during the 16th century as a result of the losses and damage suffered during the religious conflicts that resulted from the schism between the Roman Catholic and Anglican Churches under Henry VIII, and then again during the Civil War in the 17th century.

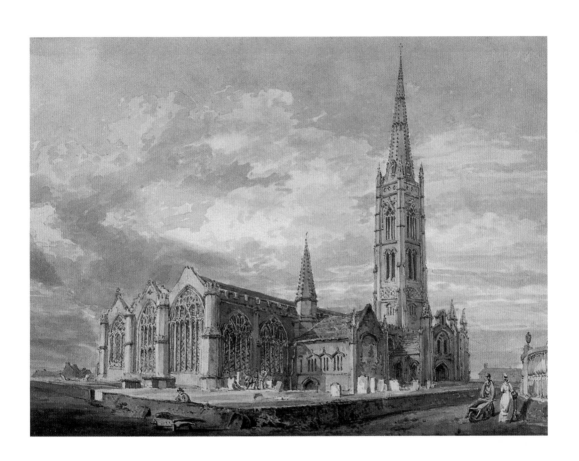

Cilgerran Castle

1798–1799

Oil on canvas, 75.5 x 93.5 cm
New Walk Museum and Art Gallery, Leicester

This is one of the three oil paintings Turner produced between 1798 and 1799 based on drawings and watercolors he did from nature during his journey to south Wales in 1798. He had visited Cilgerran on the recommendation of Sir Richard Colt Hoare, who was particularly impressed by the area. The ruins of the old castle, which had been built during the 13th century on a rocky promontory overlooking the Teifi River valley, are indeed picturesque and have inspired many writers and artists. The motif of such peaceful, lonely traces of antiquity almost lost in the midst of nature was one of the most popular subjects for young pre-Romantic poets and for artists like Turner, Thomas Girtin, and also Richard Wilson, who produced a painting from which a widely sold engraving was made. The picture shown here was sold by Turner to Joseph Gillott. On 27 April 1872 it was purchased by Leon Gauchez, a dealer from Brussels, at an auction at Christie's. The following year it went to John W. Wilson, a citizen of Brussels, and was then bought by M. Outran in the auction held on 27 and 28 April 1874 in the Hotel Drouot in Paris. On 10 May 1879 it appeared again at an auction at Christie's, when it was purchased by Albert Levy; the executors of his will offered it for sale again at Christie's on 3 May 1884. Following further changes of ownership (it belonged to, among other people, Martin H. Colnaghi and Arthur Sanderson from Edinburgh) it was offered for sale at Christie's yet again on 3 July 1908. From the collection of G. Beatson Blair of Manchester it finally came into the possession of R.B. Beckett, who sold it to the Museum of Leicester in 1955.

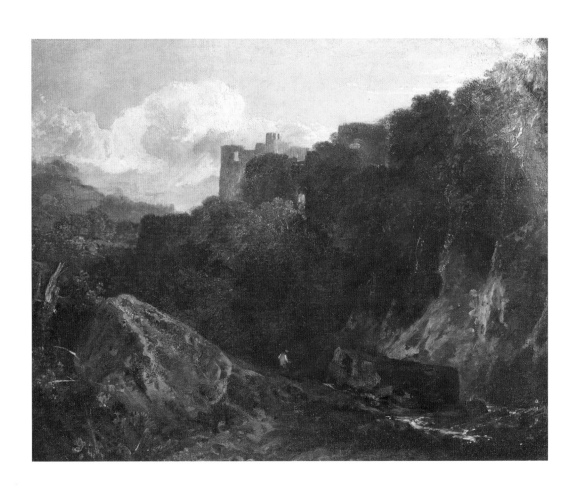

Self-Portrait

c. 1798–1799

Oil on canvas, 74.5 x 58.5 cm
Tate Britain, London

Turner produced only three self-portraits throughout his long career. The first is a small, naive watercolor painted between 1791 and 1793 (National Portrait Gallery, London). The second is an oil painting executed around 1793. Turner gave it to his governess, Hannah Danby. In 1854 John Ruskin inherited it and after several changes of ownership it was left to the Indianapolis Museum of Art in 1972. The artist still has the typical features of youth and stands with his arms folded.

The portrait shown here is the third and last self-portrait by Turner: because of his apparent age and the style employed, art historians have dated it to between the end of 1798 and the first months of 1799—shortly before the artist was elected an Associate Member of the Royal Academy. He had decided to portray himself full-face from the front, thus underlining the intensity of his gaze, which is directed proudly and determinedly straight at the viewer. His face is seen with great clarity against the dark background: he looks as if he were about to walk calmly and purposefully forward out of the picture, well aware of his abilities and sure of his future. In spite of his modest origins, which he never attempted to hide or deny, he has given himself the appearance of an aristocrat: elegantly dressed and with a well-groomed appearance, here he is a confident young man who knows how to converse with the intellectuals, landed gentry and wealthy middle classes who were his clients. It was in November/December 1799 that the artist moved his residence and studio to 64 Harley Street and thus into one of the most exclusive districts of London.

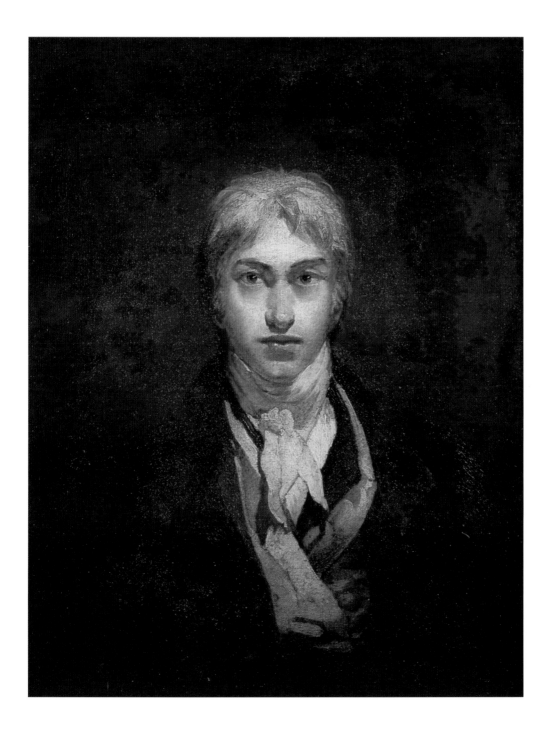

The Fifth Plague of Egypt

1800

Oil on canvas, 124 x 183 cm
Indianapolis Museum of Art, Indianapolis

Turner presented this painting at the annual exhibition of the Royal Academy in 1800, accompanied by a biblical quotation from Exodus (9: 23): "And Moses stretched forth his rod toward heaven: and the Lord sent thunder and hail, and the fire ran along upon the ground; and the Lord rained hail upon the land of Egypt." However, the painting's title is incorrect, for both the biblical text and the scene depicted refer to the seventh plague of Egypt, the Plague of Hail; in the fifth plague all the cattle die of a pestilence. The picture was judged very favorably by contemporary critics, who praised Turner's skill in representing unusual visual effects with a limited palette of colors, in particular the stormy sky and the dramatic foreground, where two horses and a rider are lying on the ground. Some critics noticed the stylistic similarity to the works of the Welsh artist Richard Wilson, especially his *The Destruction of the Children of Niobe* (c. 1759–1760, Yale Centre for British Art, New Haven), which was in the possession of Sir George Beaumont at the time. In the sketchbook in which Turner made two of the preparatory studies for this picture we also find
a sketch based on Nicolas Poussin's *Landscape with a Man Killed by a Snake* (c. 1648, National Gallery, London), then owned by Sir Watkin Williams. The white pyramid in the center of the composition could refer to the Pyramid of Cestius, which is depicted on one of the engravings by Giovanni Battista Piranesi in his *Vedute di Roma* series of 1755. Turner had the opportunity to study the latter in the house of Sir Richard Colt Hoare in Stourhead.
As the *St. James's Chronicle* of 29 April 1800 reported, the painting was purchased for 150 guineas by William Beckford, who hung it in his house in Fonthill between two works by Claude Lorrain he had purchased the previous year—an arrangement that would have delighted Turner.

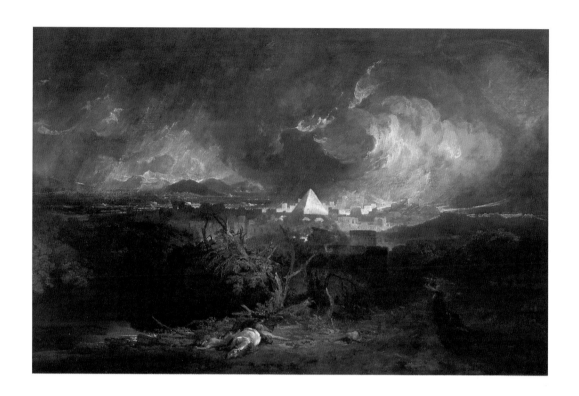

Calais Pier

1802

Oil on canvas, 172.1 x 240 cm
National Gallery, London

Possibly inspired by the requests of collectors, Turner painted several pictures between 1801 and 1805 of boats caught in a storm or in danger because of high winds or turbulent seas. In these compositions, which were very popular, he demonstrated an impressive skill for capturing a moment of narrative drama, both in his depiction of the waves—praised by those who knew the sea well—and in his precise portrayal of the attitudes of the sailors, who clearly reveal their actions and emotions. In this painting, which bears the full title *Calais Pier, with French Poissards Preparing for Sea: an English Packet Arriving*, the presence of the English post ship maneuvering and attempting to avoid a collision with a French fishing boat in Calais harbor can be interpreted on a political level, as an allegory of the fragile Peace of Amiens, which had just been signed between Britain and Napoleonic France.

This large canvas was shown in 1803 at the annual exhibition of the Royal Academy. It was highly regarded, as a review which appeared on 9 May 1803 in the British press reported and as the artist Joseph Farington recorded in his diary. The overall composition repeats some aspects of the painting *Dutch Boats in a Gale (The Bridgewater Sea Piece)* of 1801 (National Gallery, London) but also shows some similarities with two further works of 1803: *Seascape with a Squall Coming Up* (Public Library, Malden, Massachusetts) and *Fishing Boats Entering Calais Harbor* (Frick Collection, New York). Turner also painted *The Shipwreck* in 1805 (Tate Britain, London), doubtless inspired by William Falconer's long poem *The Shipwreck*, which was first published in 1762 and issued in a new edition with illustrations by Nicholas Pocock in 1804.

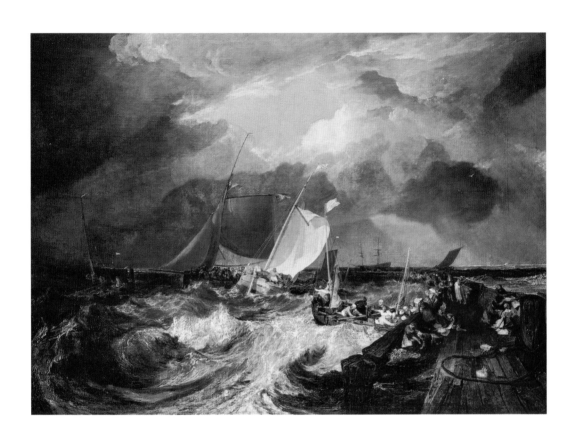

Lake Geneva and Mont Blanc

1802–1805

Watercolor, pen and ink on paper, 73.3 x 113.5 cm
Paul Mellon Collection, Yale Center for British Art, New Haven

This is one of the landscapes showing Lake Geneva with the Mont Blanc massif in the background that Turner produced using the drawings he had made during his journey in 1802, which can be found in the sketchbook *St. Gotthard and Mont Blanc*. According to John Ruskin, Turner very much liked these views because he regarded them symbolically as the gateway to the Alps, and they aroused in him a feeling of anticipation and mental preparation for his encounter with the mountains. The calm and tranquil scene, with its resting figures and animals in the foreground, creates a pastoral mood that gives the composition an Arcadian character that takes it beyond the reality of a specific time and place. At the same time, the viewer experiences the nobility and majesty of the mountains in the background to which the artist felt irresistibly drawn. This subject was so highly prized by British collectors that Turner produced a number of similar watercolors, engravings, and oil paintings over a period of years, such as his oil *Lake Geneva in Montreux* of 1810 (County Museum, Los Angeles). In the present work we can see the influence of the paintings of Nicolas Poussin, which Turner had had an opportunity to study in detail in the Louvre during his stay in Paris on his way home from Switzerland. In the landscapes of both artists we can in fact recognize the strong emotional and spiritual closeness linking them to nature, and their shared desire to create a greater degree of harmony between man and the environment in which he lives.

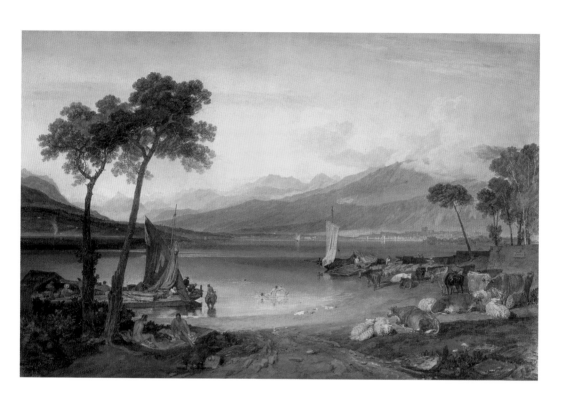

The Iveagh Seapiece, or Coast Scene of Fisherman Hauling a Boat Ashore

1803–1804

Oil on canvas, 91.4 x 122 cm
Kenwood House, The Iveagh Bequest, London

As in all his remarkable and forceful seascapes, the dramatic and exciting ones as well as the calm and joyful ones, Turner reveals his complete familiarity with the reality which he aimed to reproduce. On the one hand he studied the activities of the fishermen in order to portray realistically their clothing, equipment, boats and working methods, their gestures and habits. And at the same time he so closely observed and captured the movement of the waves, the way in which they react to gusts of wind, the color of the sea and of the reflections of sky and clouds, that viewers feel that they are truly witnessing the moment the artist has depicted. The result is a remarkable naturalness which derives from both precise, conscientious study and also spontaneity, with Turner constantly trying out new ideas, as can be seen in his numerous preparatory studies.

Turner sold the picture to Samuel Dobree in 1804, together with *Boats Carrying out Anchors and Cables to Dutch Men of War in 1665* (1804, Corcoran Gallery of Art, Washington). In 1827, when Dobree died, both paintings were purchased by Thomas, the First Lord Delamere; after his death in 1855 they were sold at Christie's on 24 May 1856 for 3,000 guineas. After the auction they were purchased by W. Benoni White, an art dealer from the Strand, for £ 2,500. On 24 May 1879 it was purchased by Agnew's Gallery at a Christie's sale; in 1888 it finally passed into the possession of Sir Edward Cecil Guinness, the future Earl of Iveagh; it was through him that the picture finally arrived at Kenwood House in 1928, where it is kept to this day.

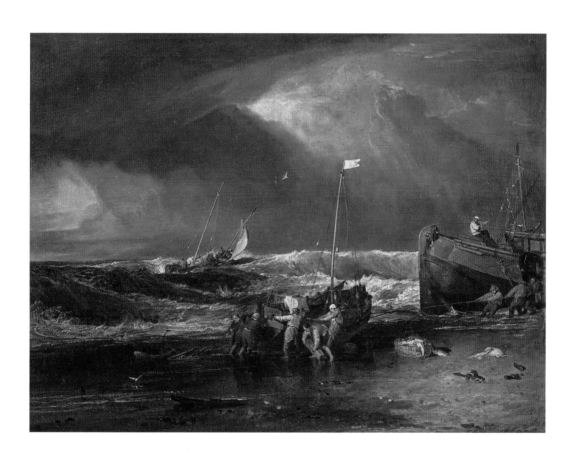

*The Iveagh Seapiece,
or Coast Scene of
Fisherman Hauling a
Boat Ashore (details)*

The Pass of St. Gotthard, Switzerland

1803–1804

Oil on canvas, 80.6 x 64.2 cm
Birmingham Museums and Art Gallery, Birmingham

During his journey to France and Switzerland in 1802, Turner wanted in particular to visit the St. Gotthard Pass, one of the most important routes across the Alps. At that time, the region was notorious because of the dangers of the route along narrow paths hewn into the overhanging rock. Turner was deeply impressed by the untamed, inhospitable landscape, which aroused both fear and admiration simultaneously to such an extent that in his eyes it embodied perfectly the "sublime" (an aesthetic concept in which a sense of awe is paramount, distinguished from both the beautiful and the picturesque). In his sketchbook, Turner executed a large number of drawings and studies of the St. Gotthard Pass and Mont Blanc, and on his return to London painted several versions in oils. The present work was commissioned by John Allnutt, a wealthy wine merchant, together with *The Devil's Bridge, St. Gotthard's Pass* (Kunsthalle Zürich), which Turner painted at the same time.

Turner's skillful use of light makes the mountains in the background look even more impressive and majestic, while at the same time deepening the sense of vertigo created by the deep, narrow gorge in the foreground by making the meager path on the left look dilapidated and unsafe. There are also two watercolor versions of the picture which are very similar in composition: *The Schöllenen Gorge from the Devil's Bridge* (1802, Tate Britain, London), and the *St. Gotthard Pass from the Devil's Bridge* (Abbott Hall Art Gallery, Kendal), which was shown in the opening exhibition in Turner's gallery in 1804 and purchased by Walter Fawkes.

Echo and Narcissus

1804

Oil on canvas, 86.3 x 116.8 cm
Petworth House, Sussex

When exhibited at the Royal Academy in 1804, this painting was accompanied by the verses from Joseph Addison's translation of Ovid's *Metamorphoses* that evoke the classical myth of Echo, the daughter of the Earth and the Air. The nymph was the confidante of Zeus's mistresses but was punished by Hera and condemned to speak only when she was asked a question. Later she fell in love with Narcissus, who however loved only himself and rejected her. Overcome with pain, Echo was transformed into a mountain stone, able to respond to the human voice only in the form of an echo.

It is likely that the artist derived the subject and the overall structure of *Echo and Narcissus* from a painting by Claude Lorrain (*Landscape with Narcissus and Echo*, 1644, National Gallery, London), that at the time was in the possession of Sir George Beaumont. The structure of the composition also reveals references to the style and expression of the French painter Gaspard Poussin, especially in the expansive landscape. Almost half of the painting is occupied by a bright, clear sky, which contrasts with the lower portion, covered in vegetation, where shadows and dark colors predominate. The work was sold to the third Earl of Egremont between 1810 and 1819. His considerable art collection and house in Petworth were inherited by the Third Lord Leconfield; in 1947 the property passed to the National Trust before being accepted by the state in 1957 in part payment of death duties. Turner produced an engraving intended for his *Liber Studiorum* based on this painting, but it was never published.

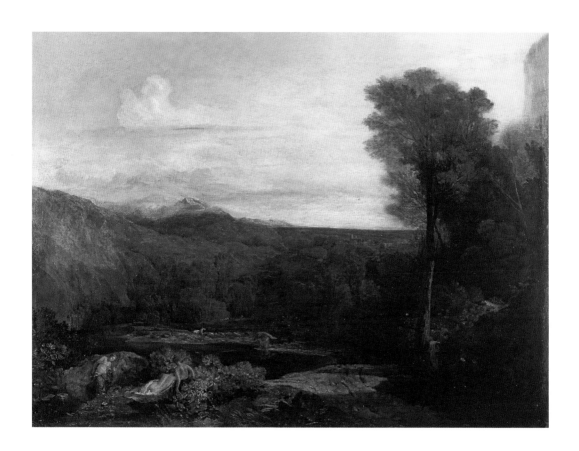

The "Victory" Returning from Trafalgar

1806

Oil on canvas, 67 x 100.3 cm
Paul Mellon Collection, Yale Center for British Art, New Haven

Turner dedicated three paintings to this celebrated subject: the painting shown here and two others, both larger: *The Battle of Trafalgar, as Seen from the Mizen Starboard Shrouds of the "Victory"* (1806–1808, Tate Britain, London), which is 171 x 239 cm; and, from much later, *The Battle of Trafalgar, 21 October 1805* (1822–1824, National Maritime Museum, Greenwich), which is 262 x 369 cm. This famous naval battle between the British and French fleets took place on 21 October 1805 off Cape Trafalgar, Spain. The fighting was over by 5 o'clock in the afternoon: the British navy had lost 450 men with 1,240 injured, but none of its ships was sunk. The French had lost 18 ships and 7,000 men were either dead or injured. British euphoria at this major victory was clouded by the death of Horatio, Lord Nelson: in the midst of the battle a French marksman perched on the mast of the *Redoubtable* shot him in the chest and broke his spine. Although he was dying, the English admiral, refusing to relinquish command, continued to issue orders to the very last. His body was brought back to England in the flagship *Victory*. A not entirely unfounded legend claims that the body was preserved in a barrel of rum that the sailors proceeded to drink after their return to London as a final act of respect to their commander.

The ship reached the Thames estuary on 22 December 1805. Turner went there in person in order to make drawings of the scene, and later produced two sketches on board the *Victory*. In the painting reproduced here he repositioned the elements and depicted the ship in three different positions, with the Isle of Wight in the background. When the artist displayed the painting in his gallery some complained that there was too little resemblance to the actual ship; they also noticed the absence of the flags at half-mast, which had indicated the presence of Nelson's body.

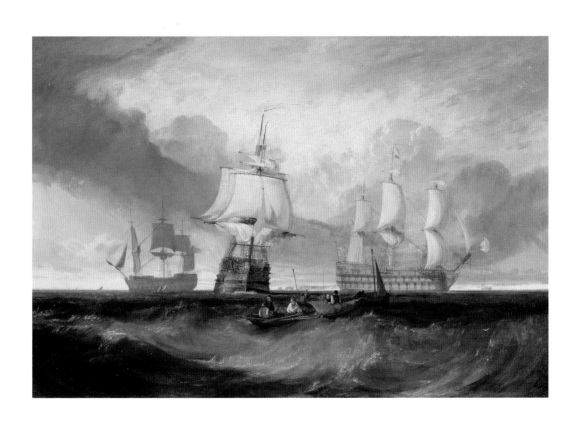

Sun Rising Through Vapour; Fishermen Cleaning and Selling Fish

1807

Oil on canvas, 134.6 x 179.1 cm
National Gallery, London

The scene Turner depicts here is typical of the coast of Holland during the 17th century, but no detail permits us to determine the precise location with any certainty. Turner shows that he had fully absorbed the manner of Willem van de Velde the Elder and his son, Willem the Younger, the undisputed masters of sea painting. However, Turner's use of light is original and personal. The light of the setting sun envelops the sea and the coast, the boats and the fishermen, with a warm, muted glow, creating an impression of extraordinary tranquility and calm.

The painting was produced with the help of a series of sketches and drawings, some of which are to be found in the sketchbook *Calais Pier*. The painting was presented to the public in 1807 at the Royal Academy's annual exhibition and it was apparently described by John Constable as "the most perfect masterpiece I have ever seen." In 1810 Turner offered it to Sir John Leicester, the future Lord de Tabley, together with three other paintings, as we learn from a letter by the artist dated 12 December. However, the negotiations were not concluded until 1818, with the payment of 350 guineas. On 7 July 1827 the work was offered for sale at a Christie's auction, and Turner purchased it back for the sum of 490 guineas, a large sum in those days. After that he decided not to sell it again and it remained in his possession until his death. He regarded it as being one of his most successful paintings. In his will of 1831 he stated clearly that he wished to donate this painting, together with *Dido Building Carthage*, to the National Gallery, on condition that the two works be hung between two paintings by Claude Lorrain: *A Seaport with the Embarkation of the Queen of Sheba* (1648) and *Landscape with the Marriage of Isaac and Rebecca* (1648).

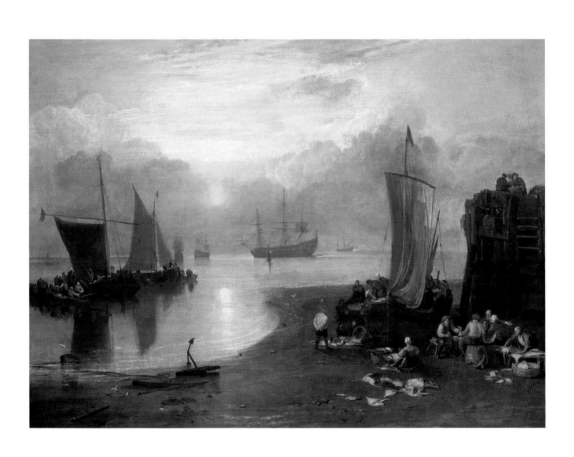

The Estuary of the Thames and Medway

1808

Oil on canvas, 88.9 x 119.4 cm
Petworth House, Sussex

This painting is one of a series of seascapes and river scenes Turner painted in 1808; others include *Spithead, Boat's Crew recovering an Anchor* (Tate Britain, London), *Margate* (Petworth House, Sussex), and *Purfleet and the Essex Shore, as seen from Long Reach* (private collection). The artist made use of a drawing in the sketchbook *The River at Margate* as well as a watercolor from the *Hesperides* sketchbook. In an article published in the June 1808 edition of the *Review of Publications of Art*, the engraver and critic John Landseer praised the vigorous painting technique, the way the town in the distance is depicted in a "cool silvery tone," and the careful arrangement of space, in which "horizontal lines impart a certain degree of steadiness which the painter values in his composition; they contrast the upright lines of his masts and rigging, and the undulating forms of his wide-weltering waves, and they serve as a foundation for the rolling clouds of his gathering tempests, or the raving zizaggery of those which the tempest has broken over the landscape." He continues: "In treating such objects as agitated seas, the motion and conduct of Mr Turner's pencil, eludes observation: your eye cannot travel along the scooped edges of his waves, as it can in the works of other marine painters. You do not know that it is a pencil which he uses: as in the works of Nature herself, you cannot tell nor trace the instrument with which the work is produced. A tempestuous sea with all its characteristic features and ever-varying forms, of foam, spray, and pellucid wave, is presented to your eye, but no man shall positively say this is the work of a pencil, or any other known instrument. You see only the presiding mind. The hand is concealed." The painting was exhibited in 1808 in the artist's own gallery, where it was purchased by the Earl of Egremont.

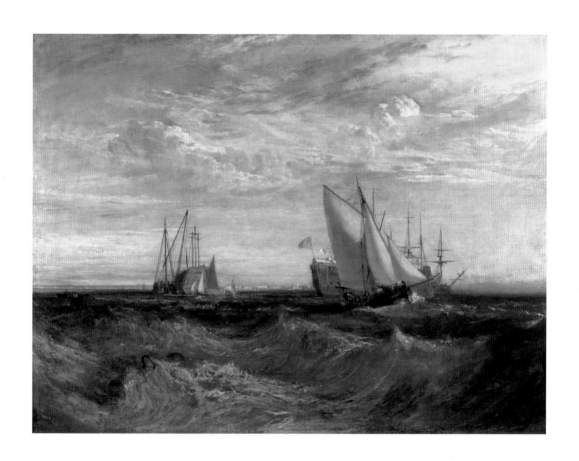

The Sun Rising Through Vapour

1809

Oil on canvas, 69.2 x 101.6 cm
The Barber Institute of Fine Arts, University of Birmingham

In order to satisfy continuing and insistent requests from customers, on a number of occasions Turner returned to the subjects of his most successful pictures, sometimes after a period of several years. He sold the painting reproduced here to Walter Fawkes. In a watercolor painted between 1818 and 1819 which depicts the drawing room at Farnlay, the home of his friend and patron, we see the picture entitled *Dort, or Dordrecht, The Dort Packet-Boat from Rotterdam Becalmed* (1817–1818, Yale Center for British Art in New Haven) hanging above the fireplace, *The "Victory" Returning from Trafalgar* (1806, New Haven, Yale Center for British Art) on the right-hand side, and the present painting on the left. It is possible that it was Fawkes himself who ordered the picture from Turner—its measurements are the same as those of *The "Victory" Returning from Trafalgar*—after seeing *Sun Rising Through Vapour; Fishermen Cleaning and Selling Fish* in Turner's gallery or at the Royal Academy exhibition in 1807. A pencil study for this paint-ing can be found in the sketchbook *Spithead*.

In *The Sun Rising Through Vapour*, the artist reveals all his skill in the use of color and tone by using a limited palette of hues: clear and brilliant in the sky and in the reflec-tions of the sun in the water, dark and muted in the lower part of the picture, where the fishermen can be seen. The composition creates a mood of utter tranquility.

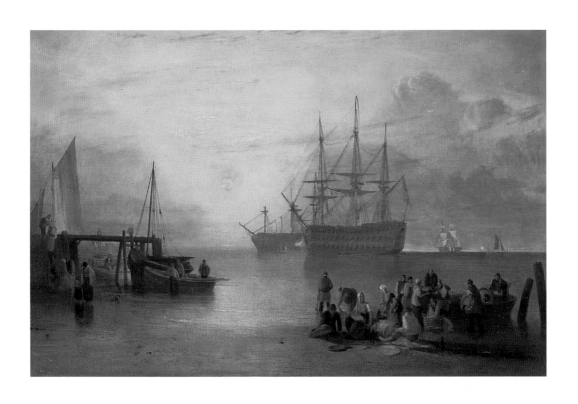

Grand Junction Canal at Southall Mill Windmill and Lock

1810

Oil on canvas, 92 x 122 cm
Private collection

The subject of this painting was almost certainly inspired by Rembrandt's *The Mill* (1645–1648, National Gallery of Art, Washington); in Turner's day Rembrandt's painting was part of the Orléans Collection, which was smuggled out of Paris and exhibited in 1799 and 1806 in the British Institution in London. Turner must have had the opportunity to study it on one of these occasions. In fact, he noted in his *Greenwich* sketchbook of 1808 that "Rembrandt is an outstanding example of meticulous care when it comes to light reflections." He also described *The Mill* as an "example of most impressive excellence."

In Turner's painting, the silhouette of the mill, with its long sails and its powerful, angular form sitting almost precariously on a conical base, stands out boldly against the reddish-orange sky, dominating the top half of the composition. In the lower section, in which the canal lock is located, the calm and peaceful appearance of the gray horse in the foreground attracts our attention while, as they go about their work, the small figures give the image a naturalistic accent. Turner has intentionally dispensed with action and movement in order to emphasize the meditative and contemplative aspect of the scene: in this way he removes reality from a specific time and place to an immaterial and spiritual dimension, fully in harmony with the new sensibility of the period and the philosophy of Romanticism.

The painting was purchased by J. Hogarth, a printer's merchant. On 14 June 1851 it was acquired by a man named Bicknell at a Christie's auction, and then after changing hands several times it finally ended up in the possession of Agnew's Gallery, who sold it to the father of the present owner.

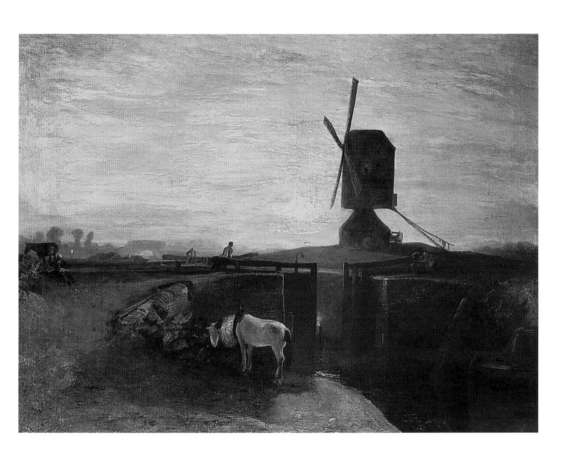

Lake Avernus: Aeneas and the Cumaean Sibyl

1814–1815

Oil on canvas, 71.8 x 97.2 cm
Paul Mellon Collection, Yale Center for British Art, New Haven

In 1798 Turner produced a picture which may have been the result of a commission from Sir Richard Colt Hoare. He used as his model a study of Lake Avernus which Colt Hoare himself executed from life in 1786. From this Turner made a preparatory pencil sketch in which he included a number of changes. The subject is the episode in Book VI of Virgil's *Aeneid* in which the Cumaean Sibyl explains to the Trojan hero that he can only journey down into Hades to meet the shade of his father Anchises if he takes with him the golden bough of a sacred tree as a gift for Proserpina.

It is not known if Hoare ever came to collect this painting. It remained in Turner's possession until his death and is now in the Tate Britain in London. In 1814, however, Hoare ordered from Turner a replica of the same subject, for which he paid 150 guineas on 25 February of the following year. In this second version (shown here), in addition to Aeneas and the Cumaean Sibyl there is a third figure, who has been identified as Chryses, the priest of Apollo; we can also see on the sarcophagus on the right Cerberus, the guardian of Hades. These two additions probably served the artist as a means of making still more obvious the contrast between Life, personified by Apollo, the god of light, and Death, represented by Hades. In 1823 Turner painted a canvas with a similar subject, *The Bay of Baiae with Apollo and the Sibyl* (Tate Britain, London), based on Book XIV of Ovid's *Metamorphoses*. In 1834 he returned to the subject once again with *The Golden Bough* (Tate Britain, London).

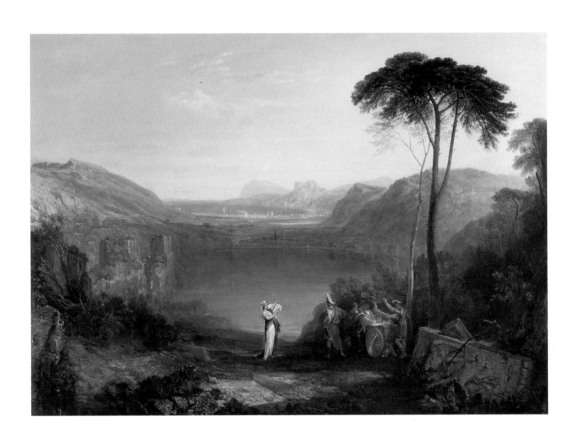

Dido Building Carthage
(or The Rise of the Carthaginian Empire)

1815–1818

Oil on canvas, 155.6 x 231.8 cm
National Gallery, London

First ideas for this painting can be found in two drawings in the sketchbook *Studies for Paintings: Isleworth*, on which Turner worked between 1804 and 1806. Surrounded by her entourage, Dido gives instructions for the building of Carthage. Before her, dressed in a dark cloak and a warrior's helmet, stands Aeneas, with whom the Queen will fall in love and who will, when he abandons her, be the reason for her suicide. On the building on the far left there is an inscription giving the title of the painting; on the tomb on the right is carved the name Sychaeus, that of Dido's first husband, who was killed by her brother. This was the reason why the queen had fled from Tyre, the Phoenician city in what is now Lebanon, seeking refuge on the coast of North Africa (present-day Tunisia).

The painting was shown at the Royal Academy in 1815 with a reference to Virgil's *Aeneid*. Critics received it enthusiastically, though there were a number of comments about the excessive use of yellow in the sky (criticism Turner partly accepted, later painting the sun over with white). However, Sir George Beaumont's judgment of the painting was entirely negative; in his opinion the picture was executed in a misguided style that did not correspond to nature. Turner was very proud of this particular work; in the first version of his will, written in 1829, he requested that he should be buried wrapped in the canvas. Nor did he wish to sell it, refusing large sums. Later, however, he donated it to the National Gallery in London on condition that it should be hung next to *A Seaport with the Embarkation of the Queen of Sheba* by Claude Lorrain, which had inspired him to paint it. In 1817 Turner produced a companion piece, *The Decline of the Carthaginian Empire* (Tate Britain, London), which contains an implicit reference to the political situation of Britain during the early years of the 19th century.

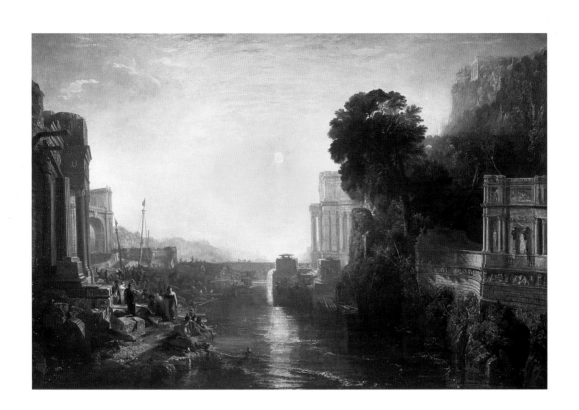

Mount Vesuvius in Eruption

1817

Watercolor on paper, 28.6 x 39.7 cm
Paul Mellon Collection, Yale Center for British Art, New Haven

During the 18th century volcanic eruptions were a common subject in art, both because of their spectacular nature and because they embodied the "sublime" to perfection—that is, that totality of strong, conflicting emotions in a viewer when confronted with natural phenomena which are particularly awe-inspiring. In 1815 Turner had exhibited an oil painting at the Royal Academy entitled *The Eruption of the Souffrier Mountains* (University of Liverpool) that was accompanied by verses Turner wrote himself. He made use of a sketch by Hugh P. Keane together with the report of the events on the islands of Barbados on 30 April 1812 that was published in the *Gentleman's Magazine*. The water-color reproduced here showing the eruption of Mount Vesuvius was commissioned by Walter Fawkes.

Again, Turner was not able to draw on his own direct experience (which he would not acquire until his first journey to Italy in October 1819); he used instead literary sources and a number of famous pictures such as those by Joseph Wright of Derby, Jacob Philipp Hackert, Jean-Baptiste Genillion, and Pierre Jacques Volaire. Turner chose a night setting to make the scene even more dramatic and terrifying. He intentionally accentuated the color contrasts between the shades of black, red, and yellow, which he used copiously, as was his custom. On the lower part of the picture he also provided evidence of his skills in depicting the countless reflections of the erupting volcano on the calm waters of the Gulf of Naples.

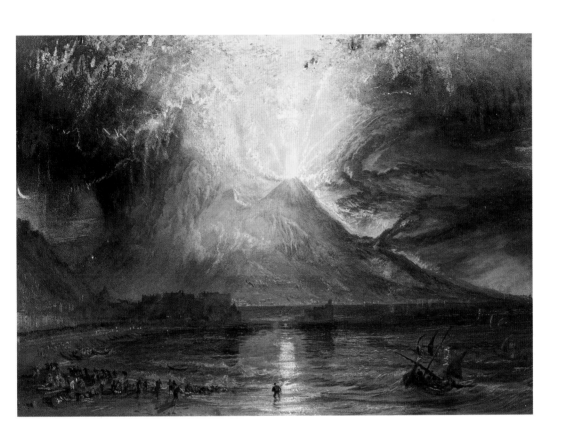

Raby Castle, Residence of the Earl of Darlington

1817–1818

Oil on canvas, 119 x 180.6 cm
Walters Art Museum, Baltimore

Throughout his career Turner spent more or less extensive periods of time staying with his patrons and supporters. From the early years of the 19th century he produced landscapes in which he placed the residence of his host in the center or in another prominent position—quite literally, "house portraits." These unusual representations soon became one of his most famous specialties and were in demand amongst an ever-increasing number of collectors. They especially valued his undoubted technical ability, but even more his poetical sensibility and his ability to give a composition a very special and original touch. He differed markedly from contemporary painters of topographical landscapes, who were sometimes more careful and conscientious in their drawing but considerably more predictable and prosaic. The painting shown here was commissioned from Turner by the Third Earl of Darlington, the future First Duke of Cleveland. The painter went to Raby Castle during the second half of September 1817 in order to make preparatory drawings from nature, which are contained in the *Raby* sketchbook. The painting was completed before April 1818.

Turner asked the owner for permission to exhibit the painting at the Royal Academy. It was virtually ignored while it was there; the newspapers of the time thought it was only a practice work. X-ray analysis has revealed that the hunting scene—the Earl of Darlington was a passionate and experienced huntsman—was originally much more extensive and compact. Turner probably reduced it so as not to distract the viewer's attention from the castle, the intended main subject of the painting.

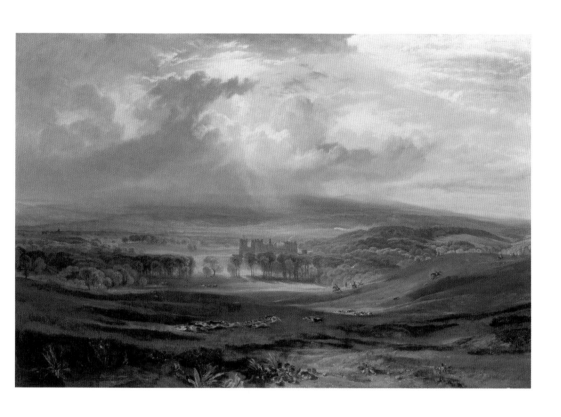

Dort, or Dordrecht, The Packet-Boat Dort from Rotterdam Becalmed

1817–1818

Oil on canvas, 57.5 x 233 cm
Paul Mellon Collection, Yale Center for British Art, New Haven

During his journey to Holland and the Rhine region in August and September 1817, Turner had an opportunity to visit Dordrecht (whose name was often shortened to Dort) in Holland. He spent one and a half days in the little town and produced numerous drawings, which he collected in his sketchbook *Rhine Journey*. For this large canvas he drew on the style of one of the great Dutch landscape painters, Albert Cuyp, who had lived in Dordrecht between 1620 and 1691; more precisely, some critics have pointed out its similarity to Cuyp's *The Moselle in Dordrecht* (1650, National Gallery of Art, Washington), which was in the possession of the Duke of Bridgewater. They have identified in particular the intense brightness of the sky and the water, which contrasts sharply with the parts of the picture in deep shadow. A further source on which the artist very probably also drew were the watercolors of the same subject by John Sell Cotman and Augustus Wall Callcott.

The river shown on the picture is the Noord, and the packet-boat in the center of the composition is *The Swan* (a swan can be seen on its flag), which sailed regularly between Dordrecht and Rotterdam. Turner chose a low viewing point in order to increase the effect of stateliness and majesty. We can see the passengers on the ships, who are taking advantage of the temporary halt brought about by the lack of wind to buy the food and drink which some enterprising local traders have brought out in rowing boats. The painting was exhibited in the Royal Academy in 1818, where it was purchased by Walter Fawkes for 500 guineas. It remained in the possession of the family until 1966, when it was sold to Paul Mellon, who donated it to Yale Center for British Art.

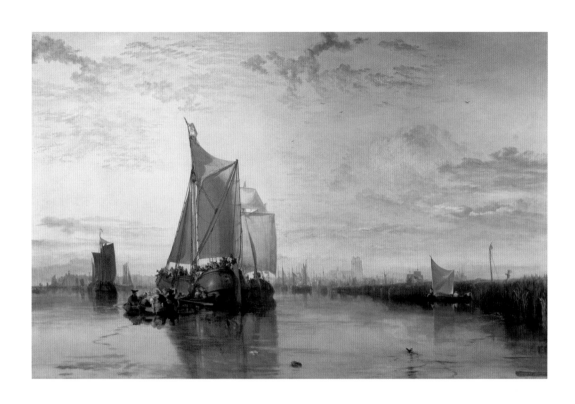

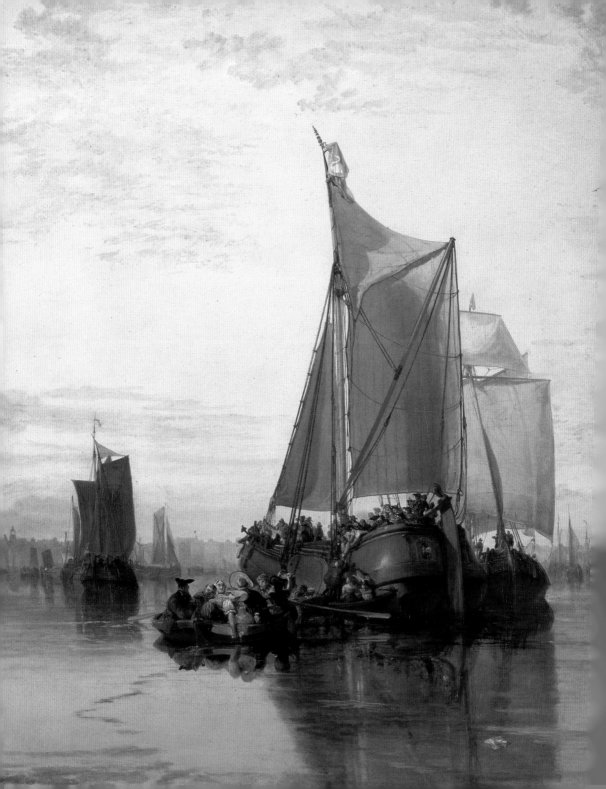

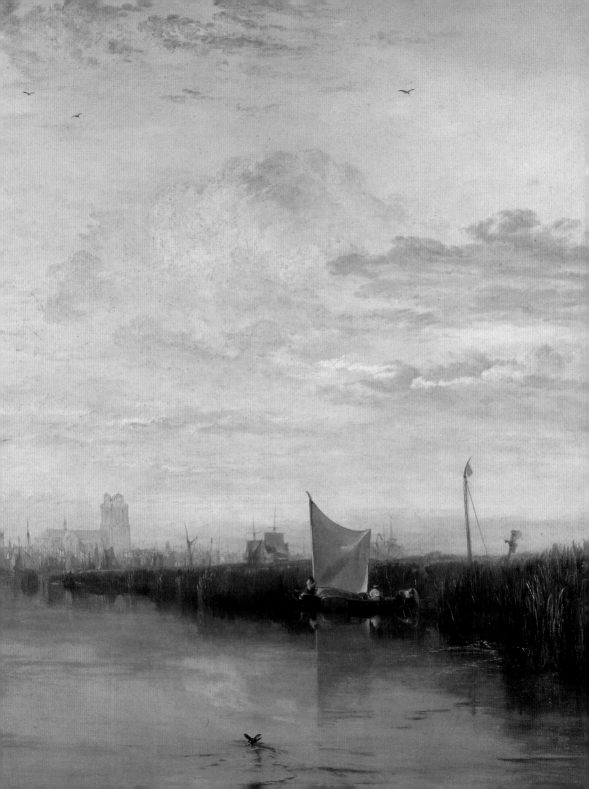

Venice: The Rialto

1820~1821

Watercolor on paper, 28.6 x 41.3 cm
Indianapolis Museum of Art, Indianapolis

Turner's representations of Venice are without doubt amongst his best-loved pictures. Although he spent only a short time in La Serenissima—during the course of three journeys a total of less than four weeks—he was deeply impressed by its unique air of enchantment and during his long career he took up the subject many times. The painting shown here is one of the four watercolors devoted to the subject of Venice he painted following his first visit between 8 and 13 September 1819.

Here the treatment is still traditional and strongly recalls 18th-century models, in particular the engravings by Antonio Visentini based on the famous cityscapes by Canaletto. The drawing is precise and careful, the colors point to exceptionally close observation, and the light is clear and bright, not only in the broad sky but also in the reflections of the palazzos and gondolas and the other boats in the water. The elegant bridge seen in the distance, the Rialto, forms the focal point of the composition. The viewing point lies fairly low and so gives viewers the impression that they are sitting in one of the boats— perhaps in a gondola—in the middle of the Grand Canal. At about the same time the artist also produced a large oil painting, *The Rialto*, which was possibly intended as a companion piece to the painting *Rome from the Vatican. Raffaelle, Accompanied by La Fornarina, Preparing his Pictures for the Decoration of the Loggia* (both Tate Britain, London).

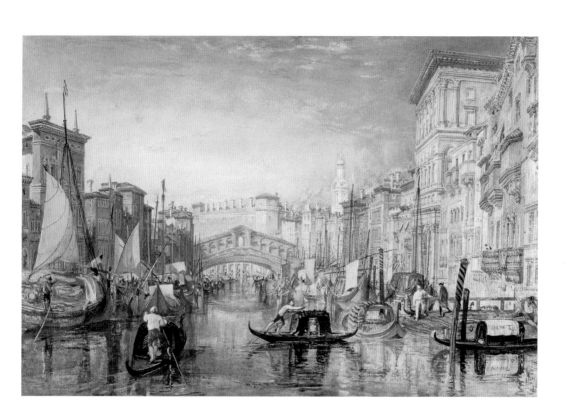

Rembrandt's Daughter

1827

Oil on canvas, 121.9 x 89.5 cm
Fogg Art Museum, Harvard University Art Museums

This is one of Turner's few oil paintings to show an interior. It was inspired by a famous work by Rembrandt, *Joseph Accused by Potiphar's Wife* (1655), which at the time was owned by Thomas Lawrence and is today in the Gemäldegalerie in Berlin. Some experts conjecture that the choice of subject was a hidden reference to the artist's private life, although that would have been very unusual for Turner. Other parallels were assumed in the lives and careers of the Dutch master and the English artist.

The picture was exhibited at the Royal Academy in 1827. As was Turner's custom, he carried out the final revisions of the painting during the days immediately preceding the exhibition, the "varnishing days." He then added red lead and vermilion in order to freshen up the colors and to ensure that the painting did not seem inferior hanging next to the *Portrait of John Wide* by Archer Shee, who would become President of the Royal Academy in 1830.

Critics praised this homage to Rembrandt and Dutch painting, which Turner had been able to study during the course of his numerous journeys as well as in the collections of his patrons and customers, but criticized the excessive brightness of the colors, which in their eyes was by no means natural.

The painting was purchased by Francis Hawksworth Fawkes; it is the only painting by Turner which was purchased by the family following the death of Walter Fawkes. In 1912 it was handed over to the art dealers Agnew & Knoedler; in the following year it was purchased by Edward Waldo Forbes, who donated it to the Fogg Art Museum in Harvard in 1917.

East Cowes Castle, the Seat of J. Nash, Esq.; the Regatta Beating to Windward

1828

Oil on canvas, 90.2 x 120.7 cm
Indianapolis Museum of Art, Indianapolis

Between the end of July and September 1827 Turner worked on the Isle of Wight. He was the guest of the architect John Nash, the owner of East Cowes Castle, which he had planned in 1789 (it was demolished during the 1960s). The artist painted two pictures for his friend: this one and its companion piece, *East Cowes Castle, the Seat of J. Nash, Esq.; the Regatta Starting for their Moorings* (Victoria and Albert Museum, London). Both compositions were preceded by a series of preparatory drawings and sketches Turner made from life, most probably on board a boat. In particular he used a single canvas measuring 182 x 122 cm on which he executed nine oil sketches. The canvas was subsequently cut up, initially into two pieces containing four and five sketches, and later—in 1905—these were divided into nine pieces, which are now preserved in Tate Britain in London. Although the title specifically refers to East Cowes Castle, the building does not form an important element in the composition but simply occupies a place in the far distance. The painter's interest is focused entirely on the regatta and the speed of the yachts as they boldly defy the wind and the waves.

The two pictures were exhibited at the Royal Academy's annual exhibition in 1828. The critics' verdicts were generally positive, although in an article published in the *Morning Herald* on 26 May 1828 Turner was accused of having made numerous technical mistakes in the representation of the boats, especially as regards the masts and the sails, which were see as out of proportion in relation to the boats carrying them. The critic also claimed that the sea looked more like marble than moving water, a comment which Turner was to hear more than once from his arch-critic Sir George Beaumont.

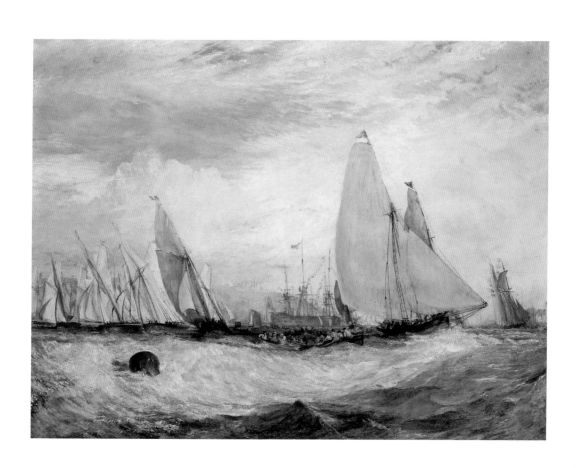

Messieurs les voyageurs on their return from Italy (par la diligence) in a snow drift upon Mount Tarrar — 22nd of January 1829

1829

Watercolor and gouache, 54.5 x 74.7 cm
British Museum, London

In the course of his journeys through Europe, Turner witnessed countless events that supplied him with material for his paintings. During his first visit to Italy between August 1819 and February 1820 he was caught in a violent snowstorm in the Alps, which he recorded in the dramatic watercolor *The Passage of Mount Cenis* (Birmingham City Museum and Art Gallery). The present composition, with its lengthy title *Messieurs les voyageurs on their return from Italy (par la diligence) in a snow drift upon Mount Tarrar – 22nd of January 1829*, dates, however, to Turner's sojourn in Italy from August 1828 until February of the following year.

The coach in which Turner was traveling while crossing the Alps on his homeward journey got caught in a snowdrift. He and the other passengers had to spend a long time outside in the snow waiting for the journey to continue. Two elements enliven the scene and make it especially exciting and atmospheric: the first is the form of the coach as it lies on its side like some huge injured animal, with people around it eagerly trying to clear away the snow. The second is the fire with its brilliant colors, which contrasts with the blackness of the night and casts an eerie glow across the snow-covered mountains and the rocky overhang which opens up threateningly before them, emphasizing the frailty and vulnerability of the travelers, who huddle together for warmth and protection.

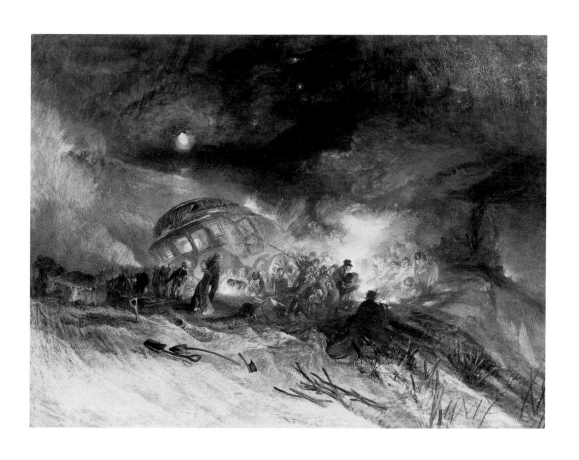

Messieurs les voyageurs on their return from Italy (par la diligence) in a snow drift upon Mount Tarrar – 22nd of January 1829 (details)

Odysseus Deriding Polyphemus

1829

Oil on canvas, 132.7 x 203.2 cm
National Gallery, London

This is one of the most important paintings in Turner's oeuvre; John Ruskin regarded it
as "the central picture in Turner's career." It depicts a scene from Book IX of Homer's
Odyssey: Odysseus and his companions have succeeded in escaping from the cave of
Polyphemus after making him drunk and then blinding him with a glowing stake. After
embarking on their ship once more, Odysseus reveals his true identity to the Cyclops and
mocks him for his guilelessness and stupidity. The warrior is shown standing on the bow
of the ship with a torch in his hand, the symbol of the hero who makes use of the light of
reason to fight against the irrational powers of nature. The Nereids in front of Odysseus'
ship and the horses drawing the chariot of the sun (which today have almost completely
disappeared) are not mentioned in Homer's poem; they were added by Turner to allude
to the role played by the gods in the hero's fate. Turner was fascinated by Greek mythol-
ogy; he loved the epic poems of Homer and would have liked to read them in the original.
However, despite considerable efforts and various attempts on his part to learn ancient
Greek, he had to make do with the English translation by Alexander Pope. The composi-
tion is based on various sketches Turner drew during a visit to Rome in December 1828.
The picture was shown in the Royal Academy exhibition in 1829 and was the object of
widely differing critical opinions: some praised the colors' powers of expression and saw
the background as one of the most beautiful skies painted during those decades; others,
by contrast, criticized the confused portrayal of the subject, the lack of fine detail in the
representation of forms, and (again) Turner's choice of colors, which they found strange
and completely "unrealistic."

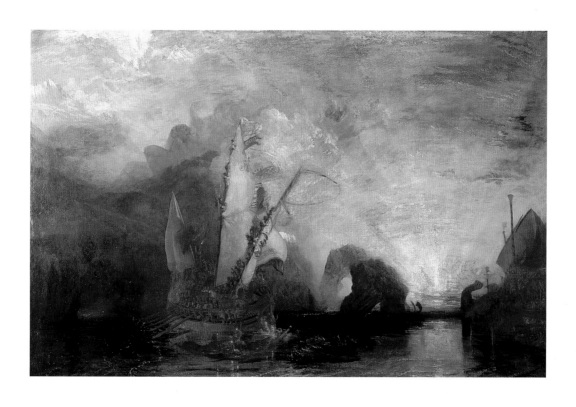

Odysseus Deriding
Polyphemus (details)

Calais Beach at Low Tide: Poissards Gathering Bait

1830

Oil on canvas, 68.6 x 105.5 cm
Bury Art Gallery and Museum, Bury

The scene is the beach at Calais in France with the silhouette of Fort Rouge on the left in the distance. The painting was exhibited at the Royal Academy in 1830. When executing this painting, Turner made use of a drawing he made in 1826, which appears in his *Holland* sketchbook, as well as a little study in the *Rivers Meuse and Moselle* sketchbook for the women in the foreground. The composition shows a number of parallels to the landscapes of Richard Parkes Bonington, especially in the use of color and the choice of subject, a broad beach at low tide. Born in Arnold, near Nottingham, on 25 October 1801, Bonington moved to Paris with his family. There he studied at the École des Beaux Arts, visited the Louvre, and established a close friendship with Eugène Delacroix. In the following years he undertook a number of journeys to northern France and specialized in watercolor landscapes, which he successfully exhibited at the Paris Salons of 1822 and 1824, where he was awarded a gold medal. His promising career was sadly ended by his premature death on 23 September 1828, aged only twenty-five.

The melancholy, tranquil atmosphere of this painting, and especially the setting sun, can be interpreted both as an act of homage and also as a moving and emotional farewell on Turner's part. He genuinely valued Bonington's paintings and considered him to be the most talented of the young British landscape painters. About 1844 Turner sold this picture along with seven other works to Joseph Gillott for £500. At the auction of Gillott's collection at Christie's on 20 April 1872, the painting was acquired by Agnew's Gallery on behalf of Thomas Wrigley, who donated it to the museum in Bury, Lancashire, in 1897.

Admiral Van Tromp's Barge Entering the Texel in 1645

1831

Oil on canvas, 90.2 x 120.6 cm
Courtesy of the Trustees of Sir John Soane's Museum, London

This is one of the four compositions Turner devoted to the Dutch admiral Maarten Harpertzoon Tromp (1598–1653), whose numerous victories against the Spanish and British fleets made a decisive contribution to the establishment of Holland as a naval power. The other three works are *Van Tromp's Shallop at the Entrance of the Scheldt* (1832, Wadsworth Atheneum, Hartford); *Van Tromp Returning after the Battle off the Dogger Bank* (1833, Tate Britain, London); and *Van Tromp Going About to Please His Masters – Ships a Sea Getting a Good Wetting* (1844, Royal Holloway and Bedford New College, London).

As was his custom, Turner chose his subject carefully in order to contrast his own style with that of the great Dutch masters of the 17th century; and at the same time he wanted to pay homage to a much-loved hero, whose popularity is proven by the epic poem dedicated to him by the Dutch poet Joost van den Vondel. In the oil painting shown here we can see Tromp's boat in the foreground as it heads for his flagship the *Aemilia*, which is shown in the distance on the right. For the details of the *Aemilia*, Turner could make use of an engraving by Danckert after a painting by Willem van de Velde. In 1645 Tromp was made responsible for the safety of the trading ship convoys that passed off the coast of Texel, the southernmost of the East Frisian Islands.

The painting was exhibited at the Royal Academy in 1831 and purchased on this occasion by Sir John Soane, who paid 250 guineas for it, as the letter and invoice which Turner sent him on 5 May 1831 show.

Life-Boat and Manby Apparatus Going Off to a Stranded Vessel Making Signal (Blue Lights) of Distress

1831

Oil on canvas, 91.4 x 122 cm
Victoria and Albert Museum, London

During a journey in 1822, and again in 1824, Turner had the opportunity to visit Great Yarmouth, a harbor on the coast of Norfolk in east England, where this scene is set. On this occasion he used a number of drawings that can be found in his sketchbook *Norfolk, Suffolk and Essex*. It was here that he met George William Manby, an inventor concerned with the problems of safety at sea. In 1816 Manby had invented the first portable fire extinguisher, which could produce three gallons (nearly 14 liters) of water projected by compressed air. He had begun his experiments after experiencing a shipwreck in 1807, and from 1813 had designed and built a special boat; small but robust, it was equipped with a mortar with which a rescue rope could be shot towards the ship in distress. Thanks to this invention, which was financed by Dawson Turner (a namesake of the painter, but not a relative), a banker from Yarmouth, Manby was elected an honorary member of the Royal Academy in 1831.

Manby was a collector of seascapes. In 1827 he commissioned from Richard Parkes Bonington the lithograph *Practical and Demonstrative Apparatus for the Prevention of Shipwrecks and for the Rescue of the Lives of Sailors who are Victims of a Shipwreck*, and it is likely that it was Bonington who suggested that Turner should paint the picture shown here.

The painting was shown at the Royal Academy in 1831 and was well received. On this occasion it was purchase by the architect John Nash. At the Christie's auction on 11 July it was acquired by someone called Tiffin, possibly on behalf of John Sheepshanks, who donated it to the museum in London in 1857.

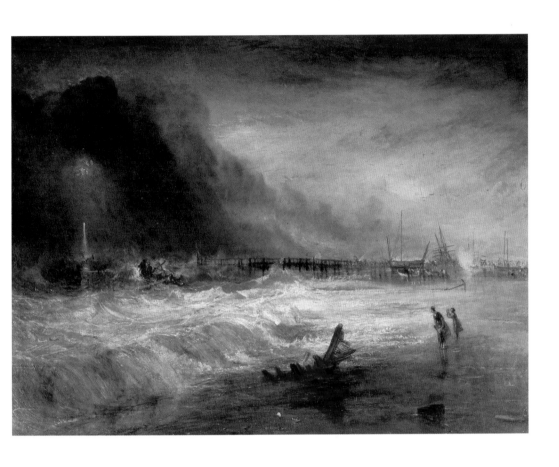

Staffa, Fingal's Cave

1832

Oil on canvas, 90.9 x 121.4 cm
Paul Mellon Collection, Yale Center for British Art, New Haven

In 1831 Turner went to Scotland at the invitation of Robert Cadell, Sir Walter Scott's publisher, in order to illustrate the poems of the great Romantic writer, whom Turner met at Abbotsford House, Scott's home. Turner also undertook a long mountain walk through the Highlands and visited the Hebrides, including Staffa, where he had an opportunity to see Fingal's Cave. He made various drawings there, one of which served as the model for an engraving Edward Goodall executed in 1834 to illustrate the tenth volume of Scott's *Poetical Works*.

A word of Scandinavian origin, "Staffa" can be translated as "pillar" and refers to a geological formation comprising thousands of natural pillars of basalt created when molten lava cascaded steeply down to the sea thousands of years ago. Completely uninhabited, the little island is famous for its seabirds, including the Atlantic (or Common) Puffin, as well as for Fingal's Cave, a grandiose geological structure of basalt pillars. The name goes back to Fingal, the mythical father of the poet Ossian. It was discovered in 1772 by Sir Joseph Banks and was very popular among Romantic artists, including Walter Scott and Felix Mendelssohn, who dedicated a famous symphonic overture to it (1830). When the picture was shown at the Royal Academy exhibition of 1832, accompanied by some verses of Walter Scott's poem *Lord of the Isles*, it was warmly received, being seen as one of the finest examples of Romantic painting. Nonetheless, the painting remained unsold for thirteen years. In 1845 it was acquired through the agency of the painter Charles Robert Leslie for £500 by James Lenox from New York and thus became Turner's first work to travel to the United States.

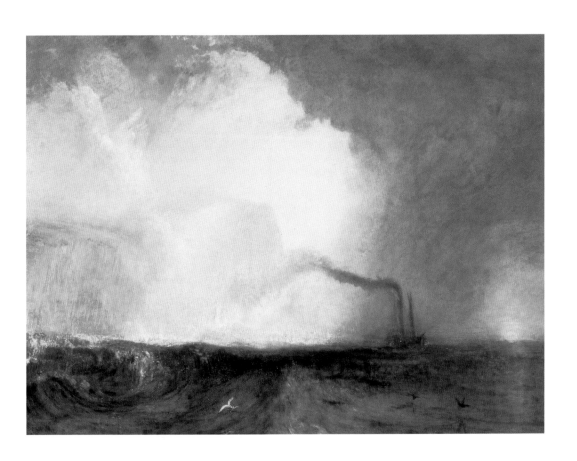

Helvoetsluys; – the City of Utrecht, 64, Going to Sea

1832

Oil on canvas, 91.4 x 122 cm
Tokyo Fuji Art Museum, Tokyo

Turner's seascapes, which were acts of homage to the great masters of 17th-century
Dutch painting, were one of his preferred subjects and among the best-loved and most
popular among his collectors and clients. The scene here is the harbor at Helvoetsluys
(or Hellevoetsluis), a port in southern Holland. We know of no preparatory drawings or
watercolors, although it is known that Turner noted the depth of the harbor in his
sketchbook *Rhine Journey* of 1817. The ship in the center of the picture is *De Stad Utrecht*
(City of Utrecht), a Dutch ship of the line armed with sixty-four guns. Turner has suc-
ceeded in depicting it with remarkable accuracy, including those technical details to
which those with nautical knowledge paid particular attention. The painting was probably
a companion piece to Turner's *The Prince of Orange, William III, Embarked from Holland,
and Landed at Torbay, November 4th, 1688, after a Stormy Passage* (1832, Tate Britain,
London).

The painting shown here was exhibited in 1832 at the Royal Academy beside John
Constable's *The Opening of Waterloo Bridge*. During the days before the opening, the
"varnishing days," Constable added a few brushstrokes in vermilion and lacquer red.
When Turner noticed, he decided he wanted to enliven his own composition, which was
perhaps dominated too strongly by shades of gray, and so added the red buoy in the
foreground. It is said that Constable commented: "He was here and fired a cannonball."

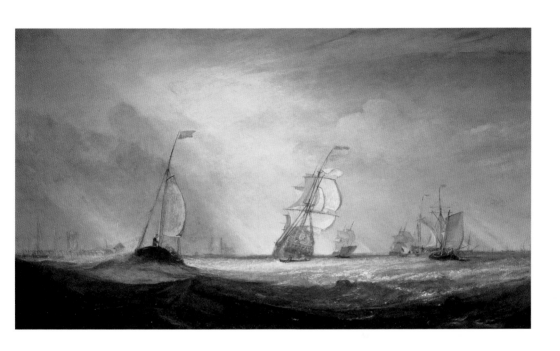

St. Michael's Mount, Cornwall

c. 1834

Oil on canvas, 61 x 77.4 cm
Russell-Cotes Art Gallery and Museum, Bournemouth

St. Michael's Mount is a rocky island which lies near Penzance on the south-west coast of Cornwall. At low tide it is connected to the mainland by a man-made causeway. It may have been a tin port in prehistoric times and later became a place of pilgrimage and the site of a priory dedicated to the archangel St. Michael. After the Norman Conquest it was placed under the aegis of the Benedictine abbey of Mont Saint-Michel off the coast of Normandy. Fortified over the years, the castle played an important role in English history. During his various journeys Turner had the opportunity to carry out numerous drawings in pencil and watercolor. Some of them are in his sketchbook *From Ivy Bridge to Penzance*, dating from 1811. Others were planned from the outset as models for engravings, such as those from his *Southern Coast* series or those produced to illustrate Sir Walter Scott's *Poetical Works*.

If we compare this painting with others Turner produced in the early 1830s, we can see that he still followed a traditional and classical structure, even if his use of color already reveals his preference for a very intense light that accentuates the contrasts between light and dark. Many critics noted his radical freedom and variety compared with his contemporaries. In an article published in the *Spectator* on 10 May 1834, an author contrasted Turner's works with those of Augustus Wall Callcott, since they were hung next to each other in the Royal Academy exhibition of that year, commenting: "The difference of these, the two first English landscape painters, is made strikingly evident. Callcott's colours look opaque and heavy, and Turner's painting unsubstantial and visionary."

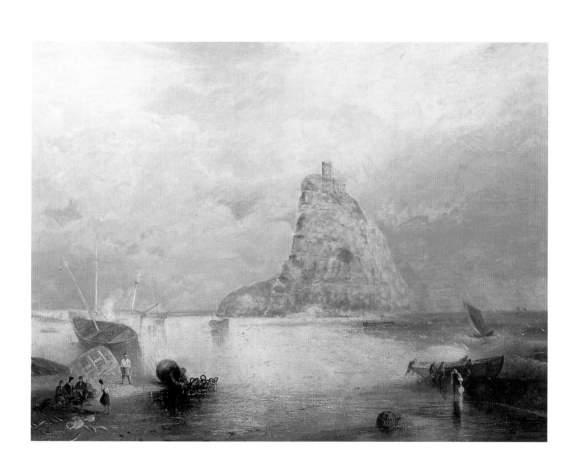

The Burning of the Houses of Lords and Commons, 16th October, 1834

1834

Oil on canvas, 92 x 123 cm
Philadelphia Museum of Art, Philadelphia

During the night of the 16–17 October 1834 a devastating fire destroyed almost the entire Palace of Westminster, the seat of the House of Lords and the House of Commons. Thousands of Londoners crowded along the banks of the River Thames and onto Westminster Bridge, shown on the right, in order to witness the dramatic—and fascinating—spectacle. According to the reports in the *Gentleman's Magazine*, they accompanied the thunderous crash as the roof of the building collapsed at 9.30 p.m. with spontaneous and instinctive—albeit inappropriate—applause.

Turner loved events of this nature, since in his eyes they perfectly embodied the Romantic feeling of the sublime. He could not miss such an exciting opportunity and so, together with Clarkson Stanfield and various students of the Royal Academy, he took up a position on board a boat and filled two sketchbooks with drawings—one in pencil and the other in watercolor. He later produced two oil paintings: the one shown here, and one which is held today in the Cleveland Museum of Art. While the drawings have a very low vantage point because they show the view from the Thames, in the oil paintings the artist adopts a higher position. He was probably influenced by dioramas that were shown in the Queen's Bazaar (Princess's Theatre) in London during the last months of 1834. Turner's picture was shown at the British Institution and according to the report by E.V. Rippingille Turner executed a large part of the painting at the exhibition location on the days reserved for the artists to put the finishing touches to their pictures. The painting was bought at that time by Chambers Hall. After numerous changes of ownership it was acquired by John H. McFadden of Philadelphia, who left it to his local museum in 1921.

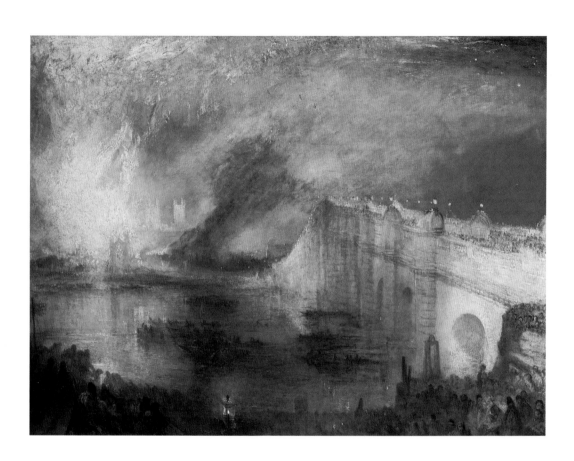

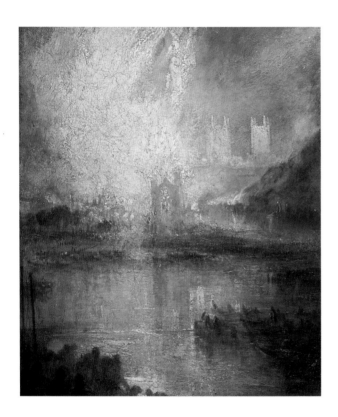

*The Burning of the
Houses of Lords and
Commons, 16th
October, 1834
(details)*

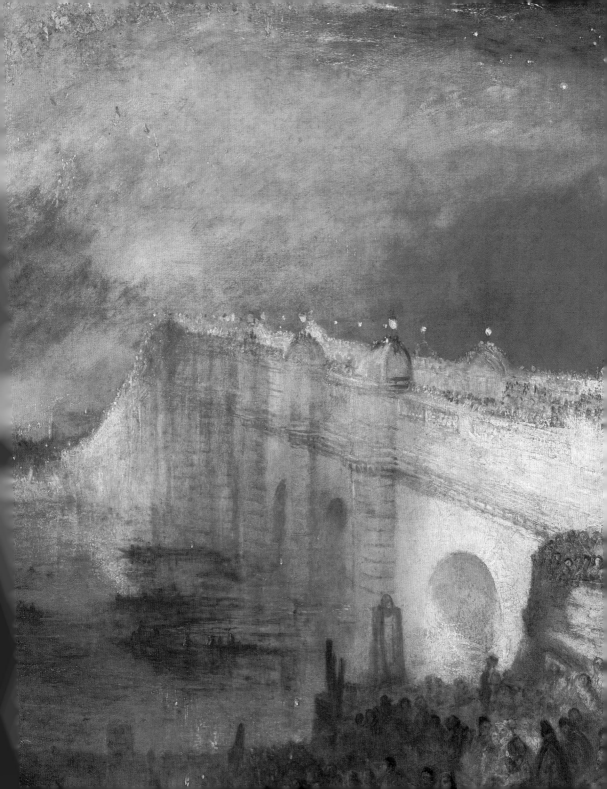

The Parting of Hero and Leander

1837

Oil on canvas, 146.1 x 236.2 cm
London, National Gallery

Turner took a long time to complete this painting. The subject was probably inspired by a William Etty painting entitled *The Parting of Hero and Leander*, which was exhibited in 1827 at the Royal Academy and in 1836 in York; it is today in Tate Britain in London. In his sketchbook *Calais Pier*, which Turner used during the first years of the 19th century, we already find a drawing entitled *Hero and Leander*, which was used for the left-hand side of this painting. Another sketch can be found in an undated letter (written before 1825) addressed to Walter Fawkes. The painting was shown at the Royal Academy's annual exhibition in 1837 and was accompanied by a number of verses explaining the scene. In attempting to swim the Hellespont to be with Hero, priestess of Aphrodite, Leander drowns and Hero kills herself. Of particular note among the numerous figures are Cynthia, with the lamp, and Amor, who is on the terrace and holding the torch of Hymenaios, the god of marriage.

In general the number of negative assessments by commentators outweighed the positive ones. The critics did not approve of the "unnatural" use of light and color, especially the luminescent white. Furthermore, viewers were bewildered at the character of the scene, which they found exaggeratedly fanciful. One critic called it "the dream of sick genius." In a letter to Thomas Griffith dated 1 February 1844, Turner expressed concern at the condition of the painting, which according to him was already endangered, and hinted at the need to have it cleaned. A few years later, when it had been added to the collections of the National Gallery in London, it was comprehensively restored in a way that was strongly criticized by John Ruskin in 1860 because, in his view, the colors the artist had selected were erroneously removed and the work's impact greatly diminished.

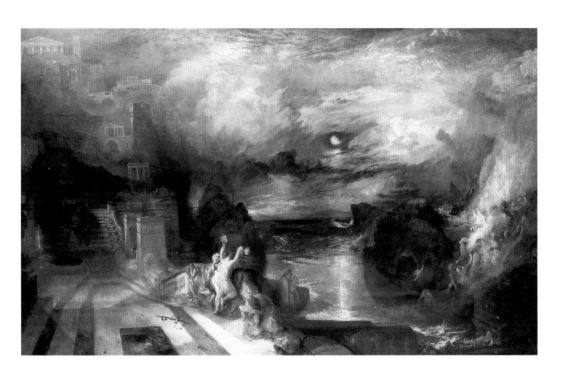

Modern Italy – The Pifferari

1838

Oil on canvas, 92.6 x 123.2 cm
Kelvingrove Art Gallery and Museum, Glasgow

The landscape shown here is a fanciful interpretation of the Campagna outside Rome and the area around Tivoli. The Pifferari were shepherds from the Abruzzi who traveled to Rome during the winter shortly before Christmas as street musicians in order to play folk music, especially of a religious nature. The painting was exhibited at the Royal Academy together with another painting, *Ancient Italy. Ovid Banished from Rome* (private collection). The intentional contrast between the subjects gave rise to various hypotheses, though Turner himself never joined in the discussion to provide an explanation. In general the reviews were negative. The *Athenaeum* commented on 12 May 1838: "It is grievous to us to think of talent, so mighty and so poetical, running riot into such frenzies; the more grievous, as, we fear, it is past recall."

Some sources claim that Turner had produced the painting for only 200 guineas at the request of the Rev. E.T. Danieli, as a concession to the limited financial means of his admirer. However, Danieli died before he could claim the picture; it was then deposited for some years (from May 1839 until the end of 1842) with the engraver William Miller for a possible etching, which however was never executed. Later the artist sold it to Hugh Andrew Johnstone Munro of Novar for the same sum that had been agreed with Danieli. After changing hands a number of times it was acquired by James Reid of Auchterarder, who left it to his son; in 1896 the latter donate it to the museum in Glasgow.

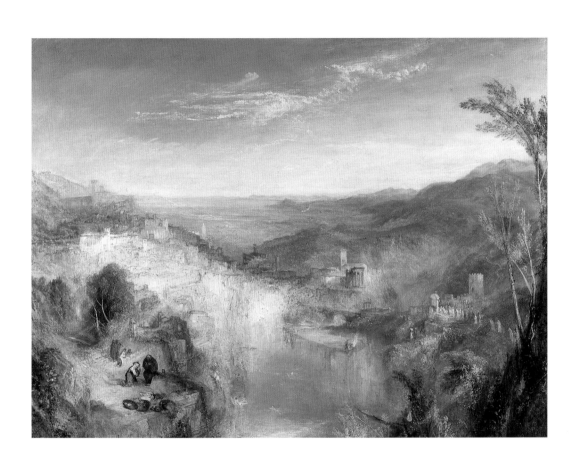

The Fighting "Temeraire" Tugged to her Last Berth to be Broken Up

1838

Oil on canvas, 90.8 x 121.9 cm
National Gallery, London

The *Temeraire*, named after a French ship which had been captured in 1759 in Lagos Bay, off the coast of Portugal, was a battleship of ninety-eight guns; launched in 1798, it played an important role in the Battle of Trafalgar in 1805. On 6 September 1838 it was towed up the Thames to the Beatson wharf in Rotherhithe to be broken up. Turner witnessed the event when he was on his way home from Margate on a packet ship, in the company of the sculptor W.F. Woodington.

The tug, driven by steam power, is a symbol of a new age, the age of the machines that were destined to supplant the old sailing ships. The rays of the setting sun are reflected with almost the same degree of intensity in the sea as between the clouds, producing an effect of unusual emotional power. There is a clear parallel between the setting sun and the sad fate of the illustrious ship which, though much revered, was nonetheless destined for the salvage-yard.

In a review published in the *Morning Chronicle* on 7 May 1839 on the occasion of the picture's presentation at the Royal Academy, a critic commented: "There is something in the contemplation of such a scene which affects us almost as deeply as the decay of a noble human being. It is impossible to gaze at the remains of this magnificent and venerable vessel without recollecting, to use the works of Campbell, 'how much she has done, and how much she has suffered for her country.' In his striking performance Mr. Turner has indulged his love of strong and powerfully-contrasted colours with great taste and propriety. A gorgeous horizon poetically intimates that the sun of the Temeraire is setting in glory." A similar verdict appeared in the *Athenaeum* on 11 May 1839: "A sort of sacrificial solemnity is given to the scene, by the blood-red light cast upon the waters, by the round descending sun, and by the paler gleam from the faint rising crescent moon, which silvers the majestic hull, and the towering masts, and the taper spars of the doomed vessel, gliding in the wake of the steam-boat ..." In the first volume of *Modern Painters* (1843), John Ruskin stated authoritatively that the painting was one of Turner's finest late works.

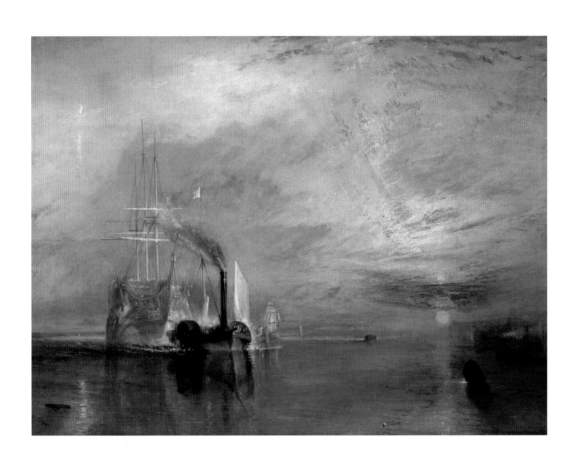

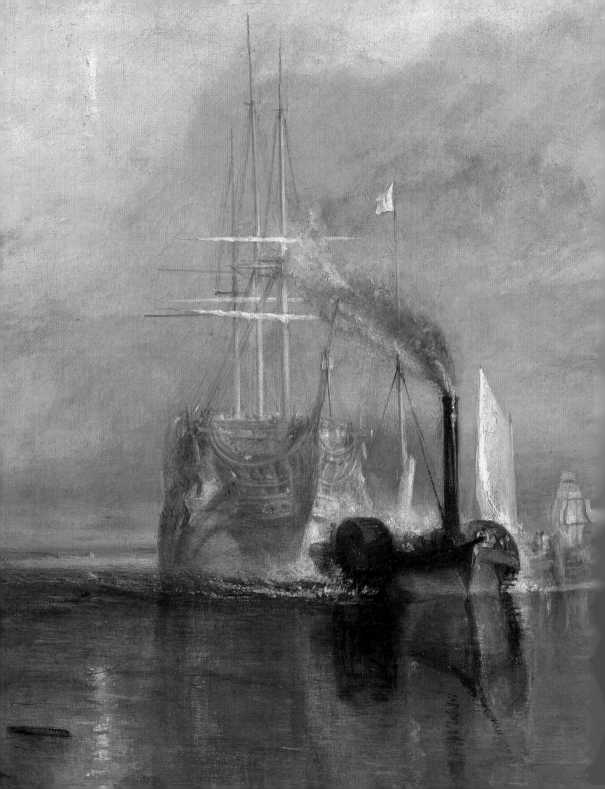

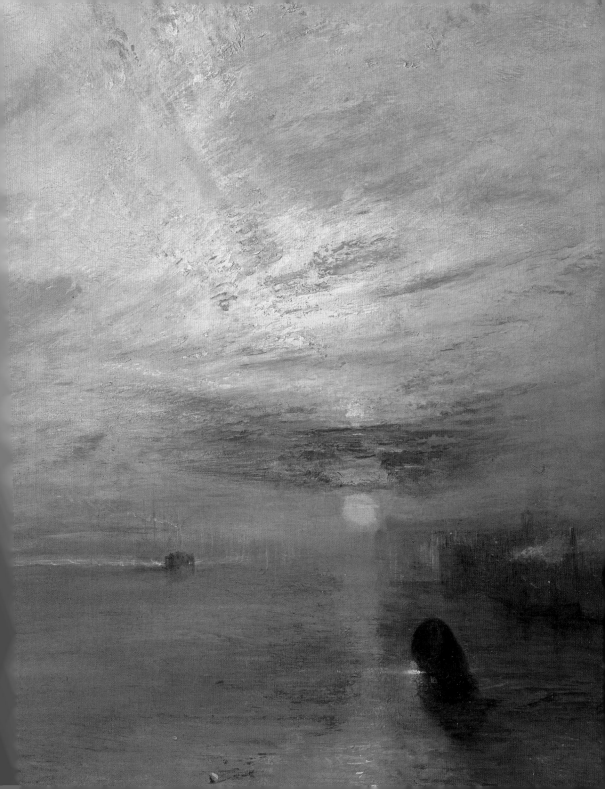

The Slave Ship – Slavers throwing overboard the Dead and Dying – Typhoon coming on

1840

Oil on canvas, 90.8 x 122.6 cm
Museum of Fine Arts, Boston

The source of inspiration for this painting, one of the most famous and most popular works by Turner, is *Summer*, a long poem by the Scottish poet James Thomson that tells of a typhoon and a slave ship. As was his custom, the artist presented the picture with a few lines from his own verse epic *Fallacies of Hope*. He was also prompted by a topical event: in 1783 the captain of the ship *Zong* was taken to court by a group of insurers who claimed that he had thrown several dozen sick slaves into the sea in order to claim compensation from the insurance company. In the picture shown here we can recognize the slave ship, which has furled its sails in order to ride out the coming typhoon. The ship's hull looks fragile against the power and violence of the waves breaking against it.

The work was executed in 1840 and exhibited at the Royal Academy, where it was widely subjected to criticism because of its "too intense" colors. Some critics ridiculed the "strange" and "unrealistic" fish devouring the drowned slaves in the bottom right-hand corner. Only John Ruskin had a high opinion of the picture and wrote in the first volume of *Modern Painters* (1843): "Nonetheless I believe that the most noble sea that Turner ever painted, and if it is so, then without doubt the most noble that has ever been painted by man, is the one in *The Slave Ship – Slavers throwing overboard the Dead and Dying – Typhoon coming on*, the masterpiece in the Royal Academy exhibition of 1840. If I were forced to consign to immortality a single work of Turner, I think I would choose this one. His colour is perfect … his shading is as real as it is wonderful."

In 1843 the painting was sold by Thomas Griffith for 250 guineas to Ruskin's father, John James Ruskin, who gave it to his son.

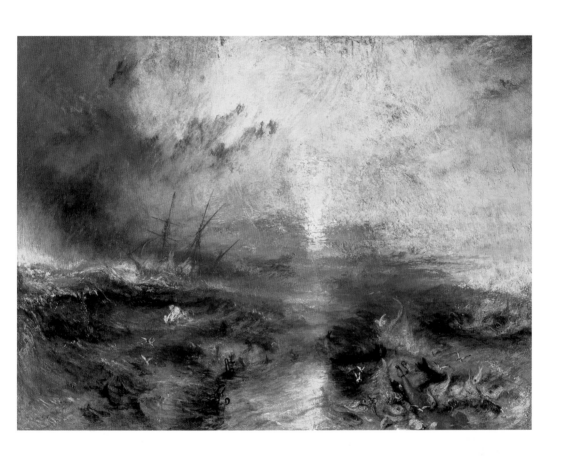

Venice, The Salute and the Doge's Palace, from Guidecca

1840

Oil on canvas, 60.9 x 91.4 cm
Victoria and Albert Museum, London

Turner was fascinated by Venice: between 1833 and 1846 he filled ten sketchbooks with hundreds of drawings and watercolors, and exhibited over twenty-five oil paintings of the city. Ranging from the lightest sketch to heavily worked canvases, these images represent one of the most important aspects of his artistic maturity. During his three visits to Venice he was especially impressed by the ethereal "floating" atmosphere beyond time and space, and by the resigned and fatalistic, almost decadent, attitude of the city with such a glorious past—a city that had lost its power and, overwhelmed by nostalgic melancholy, seemed to have withdrawn into itself and its memories. During his last visit he used his room in the Hotel Europa as a studio and vantage point from where he could admire and paint the mouth of the Grand Canal. The picture was shown at the Royal Academy exhibition of 1840 but attracted little attention. The only significant remark was published in an article in the September issue of *Blackwood's Magazine*, in which a reviewer (as so often) passed an unfavorable judgment on Turner's choice of colors. He also wrote that: "The sky is very natural, and has its due aerial perspective; all the rest is wretched: buildings as if built of snow by children in sport." While in the lower part of the picture the warm brown tones of the boats crowding the Canale della Giudecca dominate, in the upper part the church of Santa Maria della Salute on the left and the Doge's Palace in the center are white and insubstantial—as if, indeed, built of snow. Turner had been commissioned to paint the picture by John Sheepshanks, as shown by a letter dated 29 January 1840, in which the artist asked the collector for various details regarding the form and measurements of the painting.

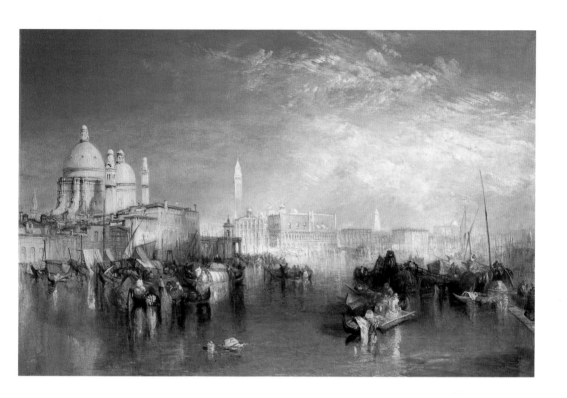

The Sun of Venice Going to Sea

1843

Oil on canvas, 61.5 x 92 cm
Tate Britain, London

In contrast to his other views of Venice, in which the artist places the most famous and typical monuments of the City on the Lagoon in the foreground, in this painting the famous palaces and churches form the background, banished into the vague distance— almost completely invisible because of the strong, dazzling light that floods the entire composition. Only the sailing boat in the foreground is portrayed with any degree of clarity, while the other elements appear undefined and hazy.

The painting was shown at the Royal Academy exhibition in 1843, accompanied by verses from Turner's epic *Fallacies of Hope*, which in turn were linked with *The Bard* by Thomas Gray and the myth of Zephyr. In the various editions of the exhibition catalogue, the artist provided several variations on his poem, but these differences confused and irritated the critics, so that the author of the review in the periodical the *Athenaeum* of 17 June 1843 wrote: "His style of dealing with quotations is as unscrupulous as his style of treating nature and her attributes of form and colour." Other critics, such as the one writing in the periodical *Art Union*, observed an intensification of the colors, especially yellow, Turner's favorite, and demanded that the artist remain faithful to nature: "Such extravagances all sensible people must condemn." John Ruskin, on the other hand, was wholeheartedly enthusiastic, writing: "The Doge's Palace is as always too white, but with delightful gradations in its relief against the morning mist. The wonderful splendour of the combination of colors in this painting make it one of Turner's masterpieces in oil."

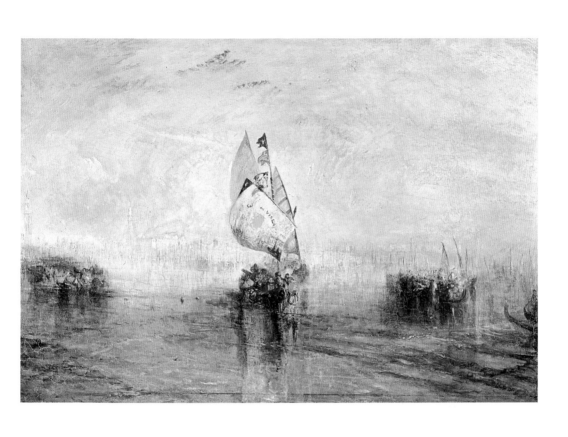

Van Tromp Going About to Please His Masters – Ships a Sea Getting a Good Wetting

1844

Oil on canvas, 91.4 x 121.8 cm
Royal Holloway and Bedford New College, Englefield Green

This painting is the fourth and last which Turner dedicated to Admiral Maarten Harpertzoon Tromp (and not *van* Tromp, as the title erroneously states). It is possible that he painted it at the suggestion of Thomas Griffith, his preferred dealer, who had noticed an increased interest on the part of collectors in Turner's works featuring ships of the past. The scene recalls an episode in the life of Tromp: on 25 July 1666, during the St. James's Day Battle between the English and Dutch fleets, he had not gone to the assistance of his superior, Admiral De Ruyter, and so the latter had relieved him of his command. In 1673 King William III succeeded in reconciling the two admirals, and Tromp was reinstated after he had made his apologies. In the painting we see Tromp's ship defying a stormy sea—a symbol of his fiery character and the effort he had to make to overcome his own pride and (even if he was not utterly convinced that he was in the wrong) to ask his commander for forgiveness; the latter's ship can be seen in the background in calm waters. On Tromp's ship is a flag with the Admiral's initials "VT"; this is an anachronism, since this only became customary during the 19th century.

Turner exhibited the painting at the Royal Academy in 1844, where the critics' opinions were, as so often, polarized: some were enthusiastic, while others were definitely negative. On 12 March 1845 Charles Birch purchased the picture for £400 from George Pennell, who had probably acquired it from Joseph Gillott. It changed hands several times before being offered at a Christie's auction on 5 May 1883 (lot no. 147), where it was acquired by Thomas Holloway, who later donated his entire collection to Royal Holloway College (now Royal Holloway and Bedford New College, Englefield Green).

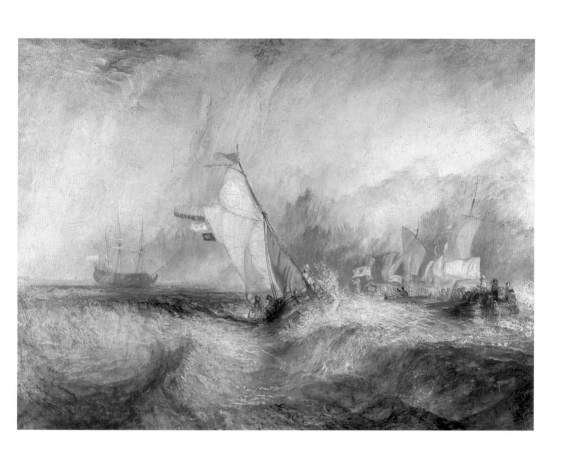

Rain, Steam and Speed – The Great Western Railway

1844

Oil on canvas, 90.8 x 121.9 cm
National Gallery, London

According to a Lady Simon, she and Turner met on a train to Devon during a thunderstorm. When a train approached from the opposite direction, the artist leaned out of the window—getting thoroughly wet—so that he could observe the effect of rain and the steam from a train traveling at speed. Lady Simon followed his example and later confirmed that the artist had completely captured the feelings which she, too, had experienced.

The engine shown here was one of the most modern of the time, known as the Firefly Class. Turner exaggerated the size and intensity of the front headlight in order to make visible the energy of the boiler, which had been heated up to maximum pressure and power. The setting is the iron bridge across the Thames at Maidenhead that was constructed between 1837 and 1839 from a design by Isambard Kingdom Brunel, one of the most famous engineers of the day. Turner himself was a shareholder in the First Great Western Railway Company and had already celebrated the power of steam as a symbol of the modern age in other paintings.

The picture was shown at the Royal Academy in 1844. Some reviewers were indignant at the boldness of the composition, but most received it positively and emphasized the artist's ability to convey a sense of speed and energy, as well as a depth of perspective and the effect of rain.

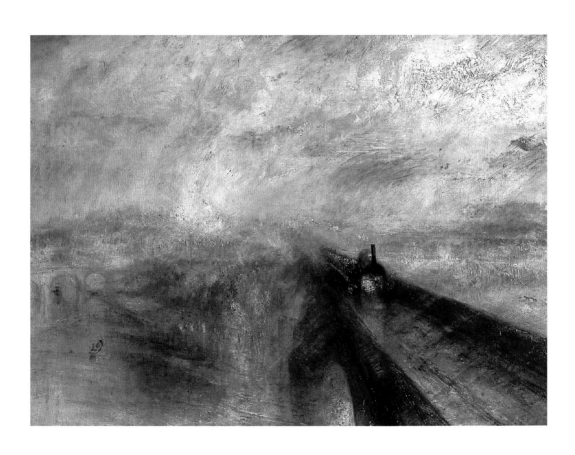

Landscape with Walton Bridges

c. 1845

Oil on canvas, 87.5 x 118 cm
Private collection

This painting, which re-works an engraving in the *Liber Studiorum*, is one of the most striking examples of the way the artist captured the poetical sensibility of the Romantic Age—especially the feeling of intimate oneness with nature—that characterize his entire oeuvre. The figures we can see in the foreground are totally at one with the landscape and their presence does not detract in any way from its peace and tranquility. The trees and the river seem unaffected by the impact of man, represented here by the bridge that occupies the central part of the picture. On the contrary, the bridge blends harmoniously with its natural surroundings. The composition, based on delicate correspondences between verticals and horizontals, is flooded by a warm and intense light which emphasizes the contrasts of light and dark and lends the work a mood that is both celebratory and tranquil—as if the feelings aroused by Beethoven's symphonies or the lyric verses of the Romantic poets had been made visible.

The picture belonged to his companion, Mrs. Booth, and later to her son, John Pound. On 24 March 1865 it was purchased by Agnew's Gallery at a Christie's auction, then by John Smith, and was then bought back again by Agnew's. In 1871 it went to John Graham of Skelmorlie Castle, Ayrshire. On 30 April 1887, after a further auction at Christie's, it was acquired once more by Agnew's, who sold it in May of the same year to J.S. Morgan, who left it to the present owner.

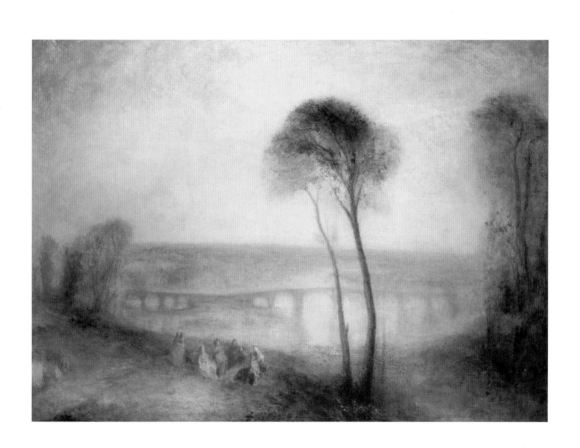

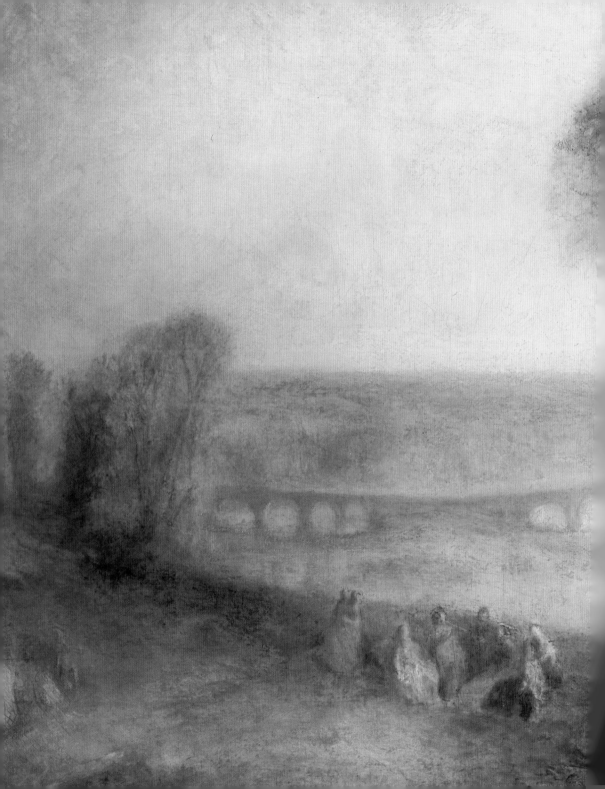

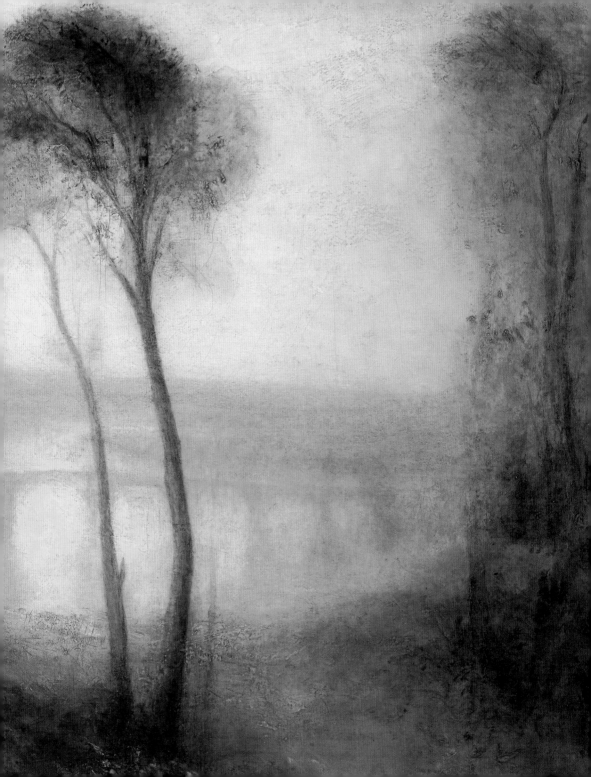

Returning from the Ball (Santa Marta)

1846

Oil on canvas, 61 x 91.4 cm
Private collection

This picture, the pendant of a painting entitled *Going to the Ball (San Martino)* (Tate Britain, London), is now in a private collection. A similar pair of paintings (Tate Britain, London) was executed a few months earlier, in 1845. It is not easy to determine the precise vanishing point of this scene, located in the Lagoon of Venice, and the few elements which we can recognize in the background do not allow us to determine with certainty which part of Venice the artist has depicted. The reference to "Santa Marta" in the title almost certainly points to a celebration that was held in Venice in connection with fishing.

The picture was purchased by Benjamin Godfrey Windus, possibly through the agency of Thomas Griffith, Turner's preferred dealer. On 20 June 1853 it was presented in an auction at Christie's (lot no. 2) and was sold for 610 guineas to Henry Wallis, a Pre-Raphaelite painter, writer and collector of paintings and ceramics. On 23 March 1854 the painting went to Joseph Gillott and was included in the sale of his collection which was carried out by Christie's on 20 April 1872 (lot no. 160), where it was purchased by Thomas Taylour, Earl of Bective, for 1,500 guineas. Later it was part of the collection of James Price, before it appeared yet again in an auction at Christie's on 15 June 1895, where it was purchased by Agnew's Gallery, who sold it to Sir Donald Currie. After changing owners several times it became part of the collection of Sir Harry Oakes, a wealthy businessman. It was offered for sale by the gallery Mallett & Son in London in 2001.

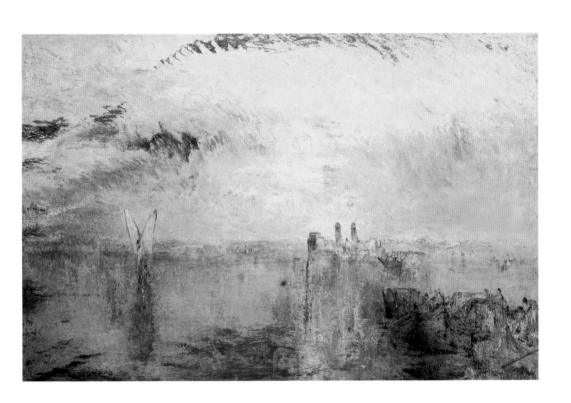

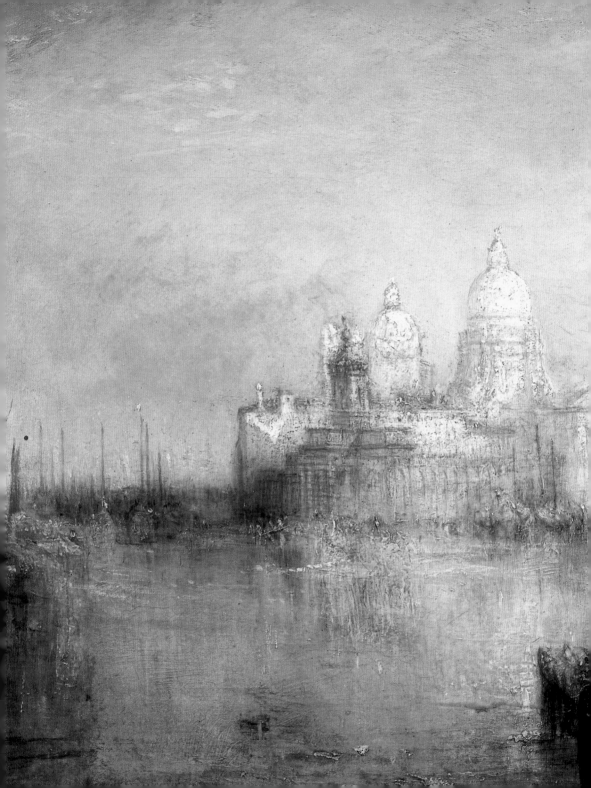

THE ARTIST AND THE MAN

Turner in Close-Up

Though one of the most original artists of the 19th century, Turner was deeply immersed in the art not only of his own day but also that of the past. Throughout his sixty years as an artist he was always keen to learn from others, and in his desire for success, both artistic and commercial, he worked in a range of popular genres and took full advantage of the art market and art institutions of his day. His development as an artist was based on a vigorous appropriation of methods and motifs.

Immediate predecessors: Monro, Cozens, and Sandby

Thomas Monro was the chief physician of the Bethlehem Hospital, to which Turner's mother was admitted. He was also the doctor who treated John Robert Cozens, one of the greatest landscape painters of the period, from whom Monro purchased numerous paintings. Between 1794 and 1797 Dr. Monro held a number of evening assemblies, usually on Fridays, to which he invited Turner and other artists, such as Thomas Girtin and Edward Dayes, so that they could study and copy some of the best works in his art collection. Direct access to Cozens' paintings, together with the long discussions with the other artists, and indeed with Monro himself, a man of wide education, were excellent incentives for the artistic and cultural development of the young Turner.

John Robert Cozens was born in London in 1725 and learned to paint from his father, the celebrated watercolorist Alexander Cozens. Since his earliest youthful attempts he had been an enthusiastic landscape painter, helping his compatriots to discover the natural beauty of Switzerland, through which he traveled in 1776, as well as of Italy, which he visited 1782–1783. His sketchbooks after nature formed the basis for a successful series of watercolors of remarkable quality, works which, characterized by finely worked details and a range of clear, light colors, also have a hint of pre-Romantic melancholy. They had a great impact in Britain and were a major influence on Turner's early paintings.

Another artist who played an important role in the formation of Turner's style was Paul Sandby, who was born in 1725 in Nottingham. He started to paint at the age of sixteen and revealed a respectable natural talent, so that the Duke of Cumberland invited him to Scotland to work as a draftsman for the engineer David Watson. Shortly afterwards he was encouraged to depict the most picturesque locations around Windsor and in Wales. He produced numerous watercolors which served as models for engravings published by Ryland & Byrce. He was not unaware of the fashion of his age for seeking inspiration in the landscapes of Italy—in those days the essential destinations of the Grand Tour—but succeeded in interpreting Italian subjects in a personal and original manner. He successfully exhibited his works in London and within a few years had established a sound reputation, thanks to his conscientious and precise landscapes, with their clear and evenly distributed light and their marked lyricism. Between 1768 and 1799 he taught drawing at the Royal Military Academy in Woolwich. He was one of the founders of the Royal Academy and is regarded as the creator of the genre of topographical watercolor painting that became very popular in Britain.

A contemporary: Thomas Girtin

Thomas Girtin, born in 1775 in Southwark in London, was the same age as Turner and enjoyed a similar training in art. After completing his apprenticeship under the direction of Edward Dayes, who specialized in topographical watercolors, he became the pupil of Thomas Malton the

Younger, with whom he was able to study the techniques and subjects of the Old Masters. Within a few years he succeeded in achieving recognition as a result of both his undoubted talent for drawing and also his instinctive sense of light and color, which enabled him to produce watercolors noted for their sensitivity. His works were admitted to the annual exhibitions of the Royal Academy from 1794, where they were well received.

He and Turner became friends and on various occasions they undertook short journeys together in order to paint landscapes side by side and exchange their ideas and impressions. In 1800 he married Mary Ann Borrett and settled in St. George's Row, Hyde Park, near the home of the painter Paul Sandby. One of the main figures in the circle of artists and writers around Dr. Monro, Girtin was a key protagonist in the discussions that helped the artists to become more aware of their abilities and to redefine their aesthetic aims and ambitions. He was also the most influential member of, and the most important driving force behind, an artists' association of professional and amateur artists who called themselves "The Brothers."

At the end of 1801 Girtin went on an extended journey of five and a half months to Paris, where he executed numerous drawings and watercolors. On his return he used them for a series of prints published posthumously in the album *Twenty Views in Paris and its Environs*. During the spring and summer of 1802 he drew a large panoramic view of London that was successfully exhibited that same year. He had many admirers, collectors, and patrons, including Edward Lascelles of Harewood House, Sir George Beaumont, and Lady Sutherland. Girtin was moving from the genre of topographical landscapes to those expressing a pre-Romantic sensibility, and he was the only painter who might have been able to compete with Turner. His career, however, which had seemed so promising, was ended by his premature death at the age of only twenty-seven in 1802.

Turner's very private life

Although we know virtually everything about Turner's career and his work, his private life is largely hidden behind a veil of reticence which his biographers have tried in vain to lift. It is as if the artist wanted to avoid influencing the attitudes of viewers and critics; as if the works had to be judged on their own merits. It is certain that he did not marry, although it is thought that from 1798 he had a relationship with Sarah Danbye, the widow of the musician John Danbye and the mother of three children. Two years later Turner supposedly became the father of a daughter, Evelina, followed by another daughter, Georgiana, who was born around 1806.

In 1829 Turner met Sophia Caroline Booth, twenty years younger than he was, who became his housekeeper in Chelsea, and then it seems his mistress. Some biographers assume that from 1833—the year in which she was widowed—Turner lived with her until he died, even calling himself at times "Mr. Booth" or "Admiral Booth." When the youthful Ruskin met the sixty-five-year-old Turner, he noted in his diary that the elderly painter had the reputation of being "coarse, boorish, unintellectual, vulgar," with an irritable temperament and an egoistic nature. Perhaps that was why Turner was neither willing nor able to have a regular family life. He most probably preferred to dedicate himself entirely to painting, his one true passion.

The golden age of English watercolors

From the first years of his long and fortunate career, Turner often used the watercolor technique, its fluid

character and immediacy of execution permitting him to capture with supreme deftness his impressions and feelings in contact with nature. Because it is a transparent medium, watercolor allows light to reflect from the support, usually paper, which means that its colors can, when used skillfully, have an extraordinary luminosity and clarity, making it an ideal medium for an artist concerned with capturing the subtle effects of light.

Turner's choice of watercolors was by no means unusual; it was in fact the expression of a taste which was widespread in Britain during the second half of the 19th century and which suited the mood and needs of the time. Watercolors were produced in great numbers. Critics had developed a keen appreciation of their qualities—they were often seen as art works in themselves and not mere studies for oils paintings—and they were much in demand among public and collectors alike, being far less expensive than oils and often depicting more familiar subjects, notably well-known views. For artist there were practical considerations, too, since watercolors are light to carry and (unlike oils) quick to dry. Before the invention of metal tubes with an air-tight cap in the mid-19th century, oil painting was only possible in artists' studios, and so the painters who wanted to paint en plein air, in direct contact with nature, could do so only if they used watercolors. Initially they were used for topographical purposes, to depict accurately views of towns and landscapes, often as records of places visited during journeys through Great Britain or Europe. The Grand Tour greatly increased the number of admirers and practitioners, professional and amateur.

By the end of the 18th century, watercolor painting—like hunting, fencing, dancing, and playing music—had become a virtually compulsory accomplishment for members of the aristocracy and the wealthy middle-classes. In order to get advice and tuition, these "dilettantes" hired famous painters, many of whom, because of the possibility of additional income, had specialized in this technique and so had achieved a very high standard. In many cases prints based on these watercolors were produced and published in the numerous illustrated periodicals fashionable at the time. In 1813 the painter David Cox published a manual entitled Treatise on Landscape Painting and Effect in Water-colours, and in 1857 John Ruskin published The Elements of Drawing. A number of societies were formed which organized regular exhibitions of watercolors, such as the Royal Watercolour Society, founded in 1804, whose exhibitions in Bond Street in London competed with those showing oil paintings at the Royal Academy. Apart from Constable and Turner, the most famous English watercolor painters of the time included Thomas Girtin, David Cox, John "Warwick" Smith, Richard Parkes Bonington, Peter de Wint, John Glover, Samuel Jackson, and John Martin. Their depictions of castles, monasteries, and abbeys, as ruins contributed greatly to the rediscovery of the Middle Ages that accompanied the emergence of the Romantic Era.

Developing from topographical views, "sentimental views" became increasingly popular, expressing the "poetic and sublime" in painting in accordance with the theory of Alexander Cozens, who had published several works on landscape painting in watercolors, notably A New Method of Assisting the Invention in Drawing Original Compositions of Landscape (1785–1786). The artists of the British School were successful in developing both the medium's technical and also its lyrical and poetic possibilities. Through their use of light and color British water-

colorists were able to capture the pre-Romantic mood and its new attitude towards nature so successfully that the British School dominated landscape painting in Europe until the middle of the 19th century, when superseded first by the French Barbizon School and then by the Impressionists.

The lure of the mountains

Turner was one of the first great painters of mountains. This genre, which mainly took the Alps as its motif, flourished from the 18th century to First World War. The rocky peaks, often covered by a permanent layer of snow, had long been regarded as something remote, unattainable, full of dangers and threats, a secret world inhabited only by wild animals, dragons, and supernatural creatures. In his *Itinera alpina tria*, first published in 1708 in London, Johann Jakob Scheuchzer, a Swiss natural scientist, devoted an entire chapter to the mythical creatures that could, he claimed, be found in those wild and remote regions. In the few cases before the 18th century in which painters depicted mountains as part of a scene, they did so in a symbolic or schematic way that bore no relation to reality. Renaissance paintings with mountains were usually by representatives of the schools emerging in Northern and Central Europe, the regions where landscape painting originated as a genre. Among the first independent landscapes featuring mountains were the watercolors Albrecht Dürer produced in 1494 during his journey to the Tyrol and Trentino, which document his lively interest in the reality of his surroundings as well as his ability to record even the smallest details. Compositions in which the mountains were no longer merely part of the backdrop but the "main actors" started to appear during the course of the 18th century. They were linked with the expansion of interest in travel through Europe, especially to Italy as the preferred, even essential, destination on the Grand Tour. Travelers from Germany, Austria, France, or Britain who wanted to visit Italy were faced in the first instance with the Alps, which in those days were very difficult and even dangerous to cross. Of course they were not the first people to cross the Alps; they were preceded by countless pilgrims, who over the centuries had made their way to Rome, the main pilgrimage destination, or the Holy Land. However, they were the first to give their journeys an aesthetic significance, as their writings and paintings testify.

These travelers often recorded their observations and thoughts in travel journals, which were sometimes illustrated by more or less detailed sketches and drawings, so that they formed a permanent souvenir of their journey. Some travelers invited scholars, writers, or artists to accompany them and to act as guides, and it is they who have left us important literary and artistic records of the various journeys. Examples include those from the journey to Switzerland which John Robert Cozens undertook in 1782 together with William Beckford; the watercolor series Sir Richard Colt Hoare commissioned from the Swiss painter Louis Ducros; and those from the journey Turner undertook in the summer of 1802. Apart from Turner, other celebrated mountain painters and travelers include William Pars, John Brett, Edward Lear, Francis Towne, Philippe Jacques de Loutherbourg, John William Inchbold, and John Ruskin, the influential art critic who was also a skilled watercolorist.

Many of these journals and paintings describe in graphic detail the difficulties the travelers suffered, the bitter cold, the often hostile weather, the countless obstacles to be overcome, the paths rough or tortuous, sometimes

barely secured or hard to follow. Some of the authors of these reports wrote (not without exaggeration) of the precipitous slopes they had to cross, the avalanches of snow and scree to which they were subjected, the snowstorms which caught them unawares, even the attack of ravenous wolves or bandits, which were by no means a rare occurrence at that time, or the desperate search for a hut or a sheltered spot where they could spend the night. At the same time, however, in addition to the fear, exertion, and exhaustion, there are often in such literary and artistic descriptions unreserved feelings of wonder and awe produced by places where nature seemed to reign supreme and where man appeared to be insignificant and forced to recognize his fragility and inadequacy. This mixed feeling of horror and fascination was described by the British dramatist John Dennis, who climbed Mont Cenis as early as 1688, observing: "I felt a delightful Horror, a terribly Joy and trembled at the same time while also experiencing an extraordinary pleasure." Such feelings were the origins of the concept of the "sublime," which would find cogent and influential expression in Edmund Burke's *A Philosophical Enquiry into the Origin of Our Ideas of the Sublime and Beautiful*, published in 1756.

The Grand Tour

During the course of his life Turner traveled extensively at home and abroad; in doing so he was following a fashion which was widespread throughout Europe, the Grand Tour. It was a phenomenon that began during the 17th century, stimulated by books such as *Coryat's Crudities* by Thomas Coryat, published in 1611, an account of an Englishman's journey through Europe and a visit to Rome and Venice. The first person to use the expression "Grand Tour" was Richard Lassels in his book *Voy-age or a Complete Journey through Italy*, published in 1670. The expression soon became popular and was used to describe the pleasure trip undertaken by wealthy young members of the European aristocracy and affluent middle classes who visited France, Germany, Austria, and Switzerland, but especially Italy, which was rich in evocative evidence of its classical past, its ruins increasingly been seen as "Romantic." The Grand Tour was regarded as an important step in the education of a young man, almost a rite of passage during which he passed from youth to manhood.

It was above all an opportunity for a more profound study of culture; since they visited the greatest Italian cities, travelers developed a deeper knowledge of other cultures. Venice, Florence, Rome, Naples, and Palermo were the compulsory ports of call, but there was not a single large town on the Italian peninsula which was not visited for its more or less important relics of ancient Rome, the Middle Ages, the Renaissance, or the Baroque—temples and amphitheaters, public and private palaces, churches and monasteries steeped in history and full of art. At the same time these adventure-loving travelers had the opportunity to visit picturesque natural scenes: from the Alps to the lakes of Lombardy, from the hills of Tuscany to the Mediterranean coast, from islands set in clear blue seas to active volcanoes. And last but not least they encountered folkloric cultures and traditions which, so different from their own, they found quaint, exotic, and the "picturesque." A sense of adventure and discovery, spiced with occasional moments of danger, made such extended journeys memorable.

The exertion and the countless tribulations, the dangers they survived, provided the experiences they would be able to draw on as adults back at home. Many of the trav-

elers carried notebooks in order to record their impressions. Sometimes they produced drawings in pencil, red chalk, or watercolor in order to show relatives and friends what they had seen, or to remind themselves of their journeys. As noted above, the wealthiest of them were sometimes accompanied by professional writers or painters whose task was to produce a journal for their client or to illustrate the main stages of the journey. Others had a portrait painted by local Italian painters or one of the (many) foreign artists living in Italy, or they bought paintings and prints showing landscapes or townscapes. The good fortune of Pompeo Batoni, Canaletto, Giovanni Battista Piranesi and many other 18th-century Italian artists can be attributed in large part to the Grand Tour—whether through the sale of their own works or through the services they provided as guides or as advisors in the purchase of artworks and antiquities, many of which found their way to the country houses of England.

George III and the Royal Academy

The Royal Academy of Art was founded in London in 1768. In contrast to the other private societies and academies already active in the English capital, it was supported by King George III. Acceding to the throne in 1760, George III inaugurated a very active foreign policy aimed at strengthening the role of Great Britain as a naval and colonial power, a policy which, despite the American Revolution and the country's declaration of independence in 1783, was largely successful. As part of his domestic policy, George III initiated radical financial and economic reforms aimed at modernizing agriculture, developing trade, and promoting industrialization. He also aimed to encourage art and culture within his kingdom in order to raise levels of education and improve technical skills.

The main aim of the Royal Academy was to provide its students with a technical and artistic education that would allow them to compete with the artists of the other European nations. The annual prizes were public signs by which the Academy acknowledged its most talented and diligent students; at the same time, the prizes clearly helped to affirm the Academy's preferred style, the "Grand Style." In his influential *Discourses*, lectures delivered from 1769 to 1790 at the Academy to mark the presentation of the prizes, Sir Joshua Reynolds, the first president of the Royal Academy, laid down the rules of the Grand Style, which were based on the close study of classical antiquity and the art of the Italian Renaissance. Artists who played an important role in the Academy, and who influenced the education of generations of painters, include Thomas Gainsborough, a skilled and sensitive creator of both landscapes and above all portraits; Sir Thomas Lawrence, president of the Royal Academy from 1820 until his death in 1830; and the Swiss-born artists Johann Heinrich Füssli, known in England as Henry Fuseli, who was celebrated for his emotionally charged, sometimes nightmarish, paintings of literary or dramatic subjects, including scenes from the works of Shakespeare and John Milton.

Within a few years the annual exhibitions, promoted and supervised by the professors of the Academy, had become a public stage with far-reaching influence, even beyond national boundaries. Closely followed by critics and the press, by art dealers and collectors, the exhibitions not only encouraged artists to improve their skills and to broaden their artistic ambitions, but in time also helped them to improve their social and economic standing.

The call of the sea

From the 17th century, Britain became a leading sea power, a position of supremacy it retained until the Second World War. Its mighty navy dominated the world's trade routes, which were used by countless merchant vessels that became progressively larger, faster and safer, transporting goods to and from the colonies, which were scattered across all continents. In Britain, as in Holland, those who had become wealthy through trade turned to artists and commissioned paintings of ships, ports, and the sea. Many Dutch artists, masters of nautical subject, were invited to England to teach British artists directly; two of the best-known and most influential were Willem van de Velde the Elder, who was born in Leiden in about 1611 and died in Greenwich, near London, in 1693, and his son, Willem the Younger, who was born in Leiden in 1633 and died in 1707, also in Greenwich.

The most important lesson they taught was the need for a precise knowledge of the sea, ships, equipment, and the weather. The artists who painted seascapes at this time, who were generally employed by trading companies or the naval authorities, often spent long periods at sea with instructions to document voyages of exploration or military campaigns. Among them were John Webber, who was engaged as official artist during Captain Cook's third voyage (1776–1779), and Samuel Atkins, who during the last years of the 18th century undertook long voyages across the Indian Ocean.

This need for accuracy meant that artists had to study subjects in close detail by means of a large number of preparatory drawings in pencil, pen and ink, or watercolor, almost always executed from life; these would be used as a guide as soon as the artist returned to his studio to execute oil paintings. The National Maritime Museum in Greenwich holds some 1,400 drawings by the Van de Veldes which the Dutch artists used for their work and which then became objects of attentive study for many of their pupils and imitators. Dutch artists inspired a great many marine paintings by British artists, those by Turner being the most outstanding examples.

Fascinated by the relationship between man and nature, and by the untamed elements, Turner produced numerous paintings with nautical subjects, from historical or contemporary battles and mythological tales to everyday scenes of fishing or trading, with boats sailing on calm seas or at the mercy of violent storms. Some of the most important sea compositions by Turner include: *Calais Pier, with French Poissards Preparing for Sea: an English Packet Arriving* (National Gallery, London), *Seascape with a Squall Coming Up* (Tokyo Fuji Art Museum, Tokyo), *The Iveagh Seapiece, or Coast Scene of Fisherman Hauling a Boat Ashore* (Kenwood House, London), *The "Victory" Returning from Trafalgar* (Paul Mellon Collection, Yale Center for British Art), *The Fighting "Temeraire" Tugged to her Last Berth to be Broken Up* (National Gallery, London and *The Slave Ship – Slavers throwing overboard the Dead and Dying – Typhoon coming on* (Museum of Fine Arts, Boston).

Turner's example was followed by many other artists who specialized in subjects related to the sea, and within a few decades schools of painting developed which specialized in a range of nautical genres from naval battles to views of coasts and harbors, from thunderstorms to fishermen going about their daily tasks, and later scenes featuring pleasure boats and regattas. Among the leading artists were Nicholas Pocock (1740–1821), William Anderson (1757–1837), Samuel Owen (1768–1857), Edward Duncan (1803–1882), and, continuing the

tradition into the 20th century, William Lionel Wyllie (1851–1931) and Montague Dawson (1895–1973).

The Romantic Era

The last decades of the 18th century were marked by profound changes in taste, mood, and sensibility which historians have named "pre-Romanticism." This was revealed not only in painting, but in all forms of culture, knowledge, science, and the arts, but especially in literature. A generation of young writers questioned the rationalism of the Enlightenment, confronting the abstraction of rational thought with what they saw as the impulsive urges of the heart. Feelings, including dark and disruptive feelings, became paramount. Early signs include, for example, Edward Young's poem *Night Thoughts* (1742–1745), and Thomas Gray's *Elegy Written in a Country Churchyard* (1751). Both mediations on death, they laid the foundations for what became known as the Graveyard School. Equally important were the "poems of Ossian," James Macpherson's supposed translation of ancient Gaelic songs. Here Homer's epics, seen for many centuries as embodiments of the values of classical antiquity, were replaced by the sagas and legends of ancient northern Europe. In general, an optimistic belief in a future steadily improved by the use of reason and science was replaced by a nostalgic longing for the past.

In Germany, the *Sturm und Drang* (Storm and Stress) movement produced new forms of poetry to express the powerful, the seemingly irresistible, demands of the passions. Particularly significant were the works of the German writer Johann Wolfgang von Goethe, above all his novel *The Sorrows of Young Werther*, published in 1774. Also widely influential was the German periodical *Athenaeum*, which first appeared in 1798. It was in the same year that William Wordsworth and Samuel Taylor Coleridge published the *Lyrical Ballads*, in effect the manifesto of the Romantic movement in Britain.

During the 18th century the term "romantic" was used to describe something unreal, fantastic, something found only in a novel (a "romance"). So it had negative connotations, suggesting a fanciful, dreamy world lacking any sense of reality. The Romantic poets appropriated the term in order to confront the rationalism of the Enlightenment with the glorification of feeling.

By the beginning of the 19th century a fully fledged Romantic movement had arisen across the arts and across Europe. This entailed a fundamental renewal of literature, art, philosophy, and customs, initially in Germany and Britain and then later in France, Italy, and finally the rest of Europe. Among the most important figures of the Romantic Age in Britain were three poets: George Gordon, Lord Byron, famous for his long narrative poem *Childe Harold's Pilgrimage*; John Keats, the creator of sensuous and yearning lyric poems such as *Ode to a Nightingale*, *Ode on a Grecian Urn*, and *Ode to Psyche*; and Percy Bysshe Shelley, whose poems, which include *Hymn to Intellectual Beauty*, *Prometheus Unbound*, and the ode *To a Skylark*, combined a passion for nature with radical politics. The desire to experience profound emotion in art found its most compelling expression in music. Frédéric Chopin was one of the most impassioned and popular composers, which is why he was known as the "poet of the piano." The alternately dramatic and sentimental moods of the period were also expressed in the music of Ludwig van Beethoven, Franz Liszt, Franz Schubert, and Hector Berlioz. Romanticism led to a new assessment of spirituality, society, history, and the individual, with life seen as a perpetual struggle between

conflicting forces, a serpentine path beset by obstacles. And those embarked on life's uncertain journey were often haunted by doubt, anxiety, or melancholy—Hamlet was frequently invoked to express the complex and contradictory moods of the age.

The attitude towards nature also changed radically: it was no longer seen as a mere machine to be explained mathematically and controlled through technology, but as a largely unknown, almost living, entity, animated by vast, awe-inspiring forces in the face of which man seemed feeble and insignificant. It was the strength of the emotions aroused by direct and intimate contact with nature, especially in its more dramatic manifestations, that fascinated the writers and artists of the period, and none more so that Turner.

The large and small Thames sketches

Among the many works by Turner in Tate Britain there are several oil paintings which are of particular interest because they permit us to understand his working methods, his techniques, and his attitude to nature. They are the seventeen preparatory sketches for the paintings he executed between 1808 and 1810; these sketches were created between 1806 and 1807 and based on drawings that he almost certainly did from nature and that can be found in the sketchbook *The Thames from Reading to Walton*. They were all painted on a dry base of white plaster, an experimental technique by means of which he hoped to achieve a greater luminosity. They have a uniform format: with the exception of one measuring 61 x 91.5 cm, they are all between 115 and 120 cm wide and between 84.5 and 91 cm high. According to some evidence which Walter Thornbury provides in his first monograph on the artist, published in 1862, Turner painted them (or at least most of them) directly from nature, which means that he was several decades in advance of the *plein-air* painting of the Barbizon School and the Impressionists. For Thornbury: "As long as you have not seen these sketches you know nothing of Turner's abilities."

According to Thornbury, they were painted in a small boat Turner used to sail up and down the Thames in search of atmospheric scenes and unusual angles for his landscapes. Turner's example was followed by that of Charles-François Daubigny, who in 1857 fitted out a floating studio which he called *Le Botin*, as well as by Claude Monet, who equipped a *bateau atelier* when he lived in Argenteuil during the 1860s, and also, later, by James McNeill Whistler, who also sailed along the Thames looking for subjects.

In addition, Tate Britain also holds eighteen studies which are painted in oil on panels of mahogany veneer, with measurements varying between 15.5 x 18.5 cm and 37 x 73.5 cm. Painted around 1807, very probably directly from nature, they represent places along the Thames and along the River Wey, based on drawings published in his *Windsor and Eton* and *Wey and Guildford* sketchbooks.

Patrons, supporters, and customers

Throughout his life Turner was a careful and adept manager of his career and his income. Born relatively poor, he nonetheless died a wealthy man. Although his art often met with incomprehension and sustained criticism, such as the open hostility of Sir George Beaumont, and despite the succession of artistic movements and changes in fashion and taste, over the decades he was able to win the appreciation of judicious collectors who became his keen patrons , supporters, and customers.

He began to show his watercolors at the age of barely fifteen. Within a few years the demand had increased to such an extent that in October 1798 the diarist and artist Joseph Farington came to the conclusion that Turner "had more orders than he was able to fulfil, and more money than he could spend." Although he continued to exhibit his works regularly at the Royal Academy and in other renowned cultural institutions, Turner opened a private gallery in which he arranged temporary exhibitions and above all received patrons and customers, showing them his works in a quiet setting well suited to discussing his art and negotiating sales and commissions. With his highly developed sense of "self-promotion," as we would call it today, Turner was adept at choosing the right time and the right place to make new acquaintances or strengthen existing relationships that were in danger of lapsing. He knew when it was best to pursue a collector and "pay court," when it was better not to press too hard, and even when to make himself scarce. He knew how to interpret the taste and feelings of the person with whom he was dealing and did his utmost to satisfy them. With calm and tenacious determination he gained the respect of the public at large and succeeded in maintaining his independence and so defending the reputation—market value—of his art.

In 1801, at the age of only twenty-six, when he sold *Dutch Boats in a Gale (The Bridgewater Sea Piece)* to the Duke of Bridgewater for 250 guineas, he was not afraid of irritating such an important person by demanding, and receiving, a further 20 guineas for the frame. He carefully and conscientiously noted every drawing, watercolor, and oil painting he sold with the amount received, the name of the purchaser, and any other information that might be useful to him in the following years. In some cases he bought back his own works for a higher sum than he had originally received for it, not because he was attached to them but in order to strengthen their current value and thus to give collectors the feeling that they had made a good investment. In 1827, for example, when Sir John Leicester's paintings were sold at Christie's in July, following his death, Turner bought back two of them: *Sun Rising through Vapour; Fishermen Cleaning and Selling Fish* (National Gallery, London), which he had sold for 350 guineas and bought back for 490; and *A Country Blacksmith Disputing upon the Price of Iron, and the Price Charged to the Butcher for Shoeing his Poney* (Tate Britain, London), which he had sold for 100 guineas and bought back for 140.

In his youth Turner was supported by numerous influential members of the British aristocracy, and in particular two men, the Third Earl of Egremont, Sir Richard Colt Hoare, and the First Earl of Harewood, Sir Edward Lascelles. At a certain point in his career, however, he made an enemy of Sir George Beaumont, whose judgment in matters of fashion and taste was highly influential at the time. Sir George's constant harsh criticism cost Turner the sympathy of many important aristocratic collectors. And perhaps this was also the reason why the British monarchy never awarded Turner a knighthood. At the same time, however, he succeeded in winning the esteem and trust of new art lovers, mostly wealthy, self-made men who began to invest the profits from their activities in trade or industry in art. Among them we find, for example, John Sheepshanks, a wealthy cloth manufacturer, who purchased five of Turner's paintings, two at an auction and three as direct commissions; Robert Vernon, who had been responsible for supplying the British army with horses during the Napoleonic wars, who owned five

works by Turner; Henry McConnell, the owner of a cotton mill in Manchester; Joseph Gillott, who had acquired a considerable fortune through the manufacture of steel springs; and Elhanan Bicknell, a whaling entrepreneur.

Turner and Ruskin: an unlikely friendship

When in 1836 Turner showed three paintings at the Royal Academy's annual exhibition, some commentators, notably the critic for *Blackwood's Edinburgh Magazine*, complained that Turner distanced himself too far from a realistic representation of nature, and accused him of being guilty of "absurdities" and a "strange jumble." John Ruskin, just seventeen at the time, wrote a reply which defended the Old Master, who was now over sixty; he sent a copy of his reply to Turner, who wrote to thank him for the "zeal, kindness and the trouble you have taken on my behalf." Born in London in 1819 as the only son of a wealthy Scottish wine merchant, Ruskin had started taking painting lessons at the age of eleven, encouraged by his father, who had given him a copy of the long poem *Italy* by Samuel Rogers, with illustrations by Turner, for his twelfth birthday. In his autobiography, the English art critic confirmed that this volume had irreversibly determined the pattern of his entire life. For him, meeting Turner did not simple satisfy a youthful ambition; it provided him with the foundation of a wide-ranging critical approach that would be immensely influential.

The two men met for the first time in June 1840 in Norwood, on the hills of Surrey not far from London, at the home of the art dealer Thomas Griffith. In his diary Ruskin noted: "Introduced today to a man who beyond all doubt is the greatest of the age; greatest in every faculty of the imagination, in every branch of scenic knowledge; at once the painter and poet of the day, J.M.W. Turner. Everyone

had described him to me as coarse, boorish, unintellectual, vulgar. This I knew to be impossible. I found him a somewhat eccentric, keen-mannered, matter-of-fact English-minded gentleman: good-natured evidently, bad-tempered evidently, hating humbug of all sorts, shrewd, perhaps a little selfish, highly intellectual, the powers of his mind not brought out with any delight in their manifestation, or intention of display, but flashing out occasionally in a word or look."

They met again three years later, on the occasion of Ruskin's birthday. Over time, Ruskin gained Turner's trust and friendship and became his staunchest defender. He also became one of the keenest collectors—he owned at least 300 drawings—and was the executor of Turner's will. In May 1843 Ruskin published the first volume of his *Modern Painters*, a milestone in modern art criticism; he had wanted to call it *Turner and the Ancients*. The central argument of his essay was the superiority of modern landscape painters, above all Turner, compared with the old—in fact relatively recent—practitioners such as Salvator Rosa, Claude Lorrain, and Nicolas Poussin. Turner was flattered, though commented to a friend: "Ruskin sees *more* in my pictures that I ever intended."

Turner's legacy

At his death Turner left an extraordinary legacy after more than sixty years devoted to painting: not only because of the huge number of works he created, but also because he had completely transformed the way of looking at nature and landscape painting, and the use of color. The lessons he taught were fundamental, not only in Britain but throughout Europe. To this day he is admired as one of the greats of Western art, from whom young artists can still gain inspiration. It is no

coincidence that the most prestigious award which an artist in Britain can receive, comparable with an Oscar in the film industry, is called the Turner Prize in his honor.

Turner had no formal pupils, but directly and indirectly he influenced a number of artistic trends in the 19th century and even the 20th century. The first "descendants" of his art were the painters of the Barbizon School in France; they, too, were enthusiastic supporters of a direct and open response to nature and a freer use of color and paint. The Impressionists followed in their footsteps, both in their preference for open-air painting and also with regard to the delicate moods created by flowing brush-strokes and soft color tones that approach those of Turner's watercolors. It is well-known that Camille Pissarro, Claude Monet, and the gallery owner Paul Durand-Ruel fled to London during the Franco-Prussian War (1870–1871) and had the opportunity to study in detail the works of the English artist, which were exhibited in the major public and private galleries. After their return to Paris they shared all they had seen with their friends and colleagues—the artists who would soon become known as the Impressionists.

During the following decades many artists studied Turner in depth, including the Fauves and the Expressionists, who learned from him to value color more highly than drawing, thus releasing its full expressive power. It was Wassily Kandinsky who took the next step; by studying closely the same source as Turner—Goethe's *Theory of Colors*—he succeeded in freeing himself from a commitment to the objective world, allowing colors to become pure expression. In Kandinsky's works the surface of the painting becomes a vibrant space in which colors have a value and significance of their own, independently of representation. Turner himself never achieved true abstraction, but he paved the way for it.

What does a Turner cost?

If he were listed on the Stock Exchange, Turner would without doubt be "Blue Chip." As he was an astonishingly prolific artist, his works appear with some regularity in commercial art galleries and at auctions the world over, earning huge sums. His drawings are naturally more affordable than his paintings, and even more affordable are prints of his works. His watercolors are quite a different matter; they cost hundreds of thousands. On 4 July 2007, for example, Sotheby's auction house in London presented fourteen watercolors by Turner from the collection of Guy and Myriam Ullens; twelve of them were sold for a total of £10,767,200, in other words over €12 million (nearly $16 million). For one of these watercolors, entitled *A Swiss Lake, Lungernsee*, the purchaser paid £3,640,000 (more than €4 million/$6 million). The current record for a Turner watercolor was set on 5 June 2006, when *The Blue Rigi (Lake of Lucerne at Sunrise)* was sold at Christie's in London for £ 5,200,000 (some €6,000,000/ $8,400,000).

Run-of-the-mill oil paintings are less expensive by comparison, since they are usually offered at auctions for €1 million to €2 million. However, the most beautiful and famous have long since been purchased by or donated to the world's greatest museums. Whenever oil paintings of great historic and artistic value are offered the collectors and institutions have no hesitation in bidding for them. The record to date is a magnificent view of Venice entitled *Giudecca, la Donna della Salute and San Giorgio*, which sold on 6 April 2006 at Christie's in New York for $32 million (€22.5 million).

Anthology

We recommend this piece [*Fishermen at Sea*], which hangs in the Ante-Room, to the consideration of the judicious; it is managed in a manner somewhat novel, yet the principle of that management is just: we do not hesitate in affirming, that this is one of the greatest proofs of an original mind, in the present pictorial display: the boats are buoyant and swim well, and the undulation of the element is admirably deceiving.

A. Pasquin (J. Williams)
Critical Guide, 1796

We here allude particularly to Turner, the ablest landscape-painter now living, whose pictures are however too much abstractions or aerial perspective, and representations not properly of the objects of nature … They are pictures of the elements of air, earth and water. The artist delights to go back to the first chaos of the world, or to that state of things, when the waters were separated from the dry land, and light from darkness, but as yet no living thing nor tree bearing fruit was seen on the face of the earth. All is without form and void. Someone said of his landscapes that they were *pictures of nothing and very like*.

William Hazlitt
The Examiner, 1816

Many other artists have studied in the school of Nature, – they are familiar with all the secrets she has ever revealed; but Turner has entered her hidden treasury, and has brought thereout "things *new*" as well as "*old*". … A picture by him is a new creation; an epic version of a passage in Nature's book. He discerns at once the *capabilities* of the landscape he sits down to paint; and

as he rapidly estimates the mode of combining them with the particular feeling the scene is calculated to excite whether as a matter of natural, moral, or historic interest; and these, as well as the identical forms before him, he determines to illustrate.

The theme of a picture, then, in the mind of Turner, is something refined and abstracted; the subject proposed is destined to be the vehicle of some classical and learned combination; some magical vision of taste, imagination and splendor. …

Yet he must not be imitated. He himself bears "a charmed life", and may venture unhurt, where the fame of others would incur inevitable destruction. He alone may play with the lion and the leopard – and yet live. He possesses that "poet's eye", that master's hand, which can give to the most unprecedented combinations, "a local habitation" and a familiar beauty; and the most sincere and *attentive* pursuer of his works, perceives that the longer they are dwelt on, the more intelligent and delightful they become. They are found to be true, *in* and *to* themselves, entire, harmonious, consistent. True also to nature, in her loveliest and most potential aspects – ideal abstractions of *conceivable* perfections.

Letter in the Birmingham Journal
12 December 1829

For the conventional colour he substituted a pure straightforward rendering of fact, as far as was in his power; and that not of such fact as had been before even suggested, but of all that is *most* brilliant, beautiful, and inimitable; he went to the cataract for its iris, to the conflagration for its flames, asked of the sea its intensest azure, of the sky its clearest gold. For the lim-

ited space and defined forms of elder landscape he substituted the quantity and the mystery of the vastest scenes of earth; and for the subdued chiaroscuro he substituted first a balanced diminution of oppositions throughout the scale, and afterwards, in one or two instances, attempted the reverse of the old principle, taking the lowest portion of the scale truly, and merging the upper part in high light.

Innovations so daring and so various could not be introduced without corresponding peril: the difficulties that lay in his way were more than any human intellect could altogether surmount. In his time there has been no one system of colour generally approved; every artist has his own method and his own vehicle; how to do what Gainsborough did, we know not; much less what Titian; to invent a new system of colour can hardly be expected of those who cannot recover the old. To obtain perfectly satisfactory results in colour under the new conditions introduced by Turner would at least have required the exertion of all his energies in that sole direction. But colour has always been only his second object. The effects of space and form, in which he delights, often require the employment of means and method totally at variance with those necessary for the obtaining of pure colour. It is physically impossible, for instance, rightly to draw certain forms of the upper clouds with the brush; nothing will do it but the pallet knife with loaded white after the blue ground is prepared. Now it is impossible that a cloud so drawn, however glazed afterwards, should have the virtue of a thin warm tint of Titian's, showing the canvas throughout ...

John Ruskin
Modern Painters, I, 1844

Though Turner was a reckless experimentalist, he was a very brilliant experimentalist, full of ideas and perpetually trying to realize his ideas. In fecundity of conception the old Dutchmen and Venetians are not to be compared with him for an instant. The regular old-fashioned system of painting, the system which enabled the old masters to reach such great technical excellence, was first to learn to paint from a clever man, and then to apply the art to five or six subjects, to be repeated in different forms till the artist died of old age. If Turner

had done this, if he had restricted himself to a narrow speciality and paid careful attention to technical matters, and had a good technical training at the beginning, his work might have been as good as that of any old master, but criticism has little concern with what might have been. As it is, criticism can only say that his experiments were always interesting, and often in the highest degree astonishing and wonderful, but seldom quite satisfactory, except in parts. I have mentioned, as a reason for this deficiency, which it is useless to try to blink, the wide range of Turner's experiments; but there is another reason for it. He was always trying to paint the unpaintable, which the Dutch and the Venetians most prudently and carefully avoided.

Philip Gilbert Hamerton
The Life of J.M.W. Turner R.A., 1879

Where Constable *observed* Nature, Turner identified himself almost pantheistically with her. The tangible world of plains, mountains, glaciers, clouds, and tempestuous or calm seas, provides him with a firm basis; yet all these seem to be caught up and transformed by the forces of nature. Where Constable recorded the particular weather of the particular day, Turner generalized his weather, as though it were a manifestation of a mythology of his own discovering.

The French Impressionists naturally admired Constable more than Turner, for their whole intention was to be accurate, not impressive. Yet in the end they came nearer to Turner than to Constable. Monet, at the end of *his* life was producing work that had a strange resemblance to Turner's, though he arrived at his destination by a different route. The west front of Rouen Cathedral, seen through the red haze of sunset viewed by the analytical eye of Monet, was very like the same scene viewed by the romantic eye of Turner.

Eric Newton
European Painting and Sculpture, 1941

Looking into a book of Turner will impart something of the same sensation, but nothing can compare with walking into the great Turner galleries of the Tate. The sensation is not an aesthetic one but a human one. You feel immersed in the very being of a personality. It is like acquiring all at once a lifetime of a close family

relationship. The ideal classical painting is as impersonal as Poussin — the person simply does not exist behind the canvas. A gallery full of Poussins would be a gallery full of independent objects of art which might just as well have grown naturally like crystals. Only the full impact of room after room of intensely personal and expressionistic paintings like Turner's can bring home the full meaning of expressionism, personalism.

It is this personal power and personal integrity, fully as much as the plastic originality, which almost immediately override Turner's taste.

Kenneth Rexroth
The Art Digest, February 1955

At the beginning of the nineteenth century two English landscape painters, John Constable and J.M.W. Turner, demonstrated through their works what the attitude of modern man towards the reality of nature might look like. After a famous exhibition of English art in Paris in 1824 their works had a decisive influence on the birth and early development of French Romanticism. The two artists had a very different training: Constable's starting point was the study of the objective Dutch landscape, while Turner began with the tradition of classical and historic landscapes of Claude and the perspective *vedute* of Canaletto. For Constable there is no universal space which is given from the outset and which is unchanging in its structure: his space is constructed of things (trees, houses, water, clouds) which are seen as patches of color which the painter attempts to depict directly by making use of a rapid technique. For Turner there is always from the outset the intuitive awareness of a universal or cosmic space which becomes concrete, and he devoted himself to the perception of special "motifs." Constable aims to make a clear distinction between the patches of color and their different qualities, which correspond to the things and thus translate the emotion into concrete knowledge (for example the red of a house in the description of the house); to relate precisely the "value" of the individual colored signs and their relationships, which together form the space. For Turner, on the other hand, the space is the endless expanse which is brought to life through the movement of vast cosmic powers, so that the things are drawn into the maelstrom of air and light

in order to be ultimately sucked up and destroyed in the rhythm of universal movement.

Giulio Carlo Argan
L'Arte Moderna: 1770–1970, 1970

This was also the great age of the discovery of power, as nature's energy sources of wind, sun, water, steam and coal were a tapped to drive the industrial revolution. And the new concept of nature as the carrier of energy, which revitalized science, also took hold of the Romantic poets and painters. The idea that nature is the source of power, whose different forms are all expressions of the one central force – energy – is as powerful in Turner's paintings as it is in the poetry of Coleridge and Shelley. J.M.W. Turner ... identified with the savage, uncontrollable aspects of nature, its destructive force and man's impotence in the face of it. He was passionately interested in the sea, one of the most powerful embodiments of the forces of nature. And in trying to express these underlying elemental forces instead of merely external appearances he arrived at his own unique kind of abstraction, constructing paintings out of light and colour, without solid outlines which had hitherto been considered obligatory.

Konstantin Bazarov
Landscape Painting, 1981

There can be little doubt that Turner took pleasure in these contrasts. He was fond of pairing pictures of opposing themes or appearance – ancient and modern, pale and dark – whose imagery enhanced each other. They were, in part, his response to a time of rapid and disturbing changes in Britain and the wider world. His formal studies began in the year of the French Revolution; his career prospered against the dangerous background of the Napoleonic War; and he died in the year of the Great Exhibition in which his country celebrated its hard-won industrial and imperial hegemony. Throughout, he had witnessed Britain transform herself, both for good and ill, from a rural to an industrial and urban society. The observant artist could not fail to be struck by the diversities around him. But Turner's sheer range of achievement ensured that there could be no narrow consistency in his work. His output – oils, watercolours, prints, poetry – never ceases to amaze;

nor do his many interests and subjects – history from ancient to modern, landscape from the ideal to the naturalistic in Britain and as far afield as possible in Continental Europe, marine, literary illustration, or images of modern life that lay outside the established categories of art but were instantly definitive.

David Blaney Brown
Turner in the Tate Collection, 2002

Turner's original public, who saw only the exhibited and engraved pictures, found it easy to admire his early works because they were highly skilled, descriptive and easily placed within the existing tradition of landscape painting. His style changed so dramatically over his career, however, that many of the later oils ... often produced bafflement and hostility. Their chromatic brilliance, unconventional compositions, scant detail and emphasis on the material qualities of the paint itself were unparalleled in contemporary British art. To his detractors these qualities seemed perverse; they variously dubbed him "the William Blake of landscape painters" (Blake's name was a byword for the irrational and eccentric), castigated him as a bad example for young artists, and memorably likened his pictures to the contents of a hospital spittoon. Time has reversed these judgements, and Turner's later paintings now hold few terrors for a public familiar with the development of Modernist art. Hindsight allows us to compare his output with the later artists' work from Monet to Rothko ... His contemporaries knew him to be a complex artist, and if they found some of his work difficult to understand, it was for good reasons: in his attempt to communicate complex meanings he sometimes made unreasonable demands of them.

Barry Venning
Turner, 2003

Another voice of the Romantic Age, William Turner, expresses in his painting the irrational attraction of natural phenomena, which evoke feelings of fear and inadequacy. Turner is fascinated that Reason cannot reign supreme, by the natural elements which demonstrate in their untamed strength their supremacy over Man. In this respect he is one of the great interpreters of the poetry of the sublime in painting. Turner himself maintained that his paintings, inasmuch as they appear fanciful, are always based on a personal experience, a vision, an emotion felt. In his incredibly long and fertile career Turner progressed from a classical painting style closely tied to the poetry of the Picturesque, which aimed at the simple observation of the countryside and the changes of mood, to a painting in which the episode related, whether historical or chance, blends with the landscape which threatens with all its evocative powers.

Marco Bona Castellotti
Percorso di storia dell'arte: dal neoclassicismo ai minimalisti, 2004

But something has started to happen in Turner's watercolours that would take him beyond the norms of Romantic scenery. The 'colour beginnings', which did indeed begin at exactly this time, were, of course, not for any kind of display ... Although modern abstract art co-opted the loose transparent scrims of colour as the inaugurators of non-figurative painting, Turner never thought about them in that way. They were free experiments with stains, washes and bleeds from which he would work up a more finished figurative composition. ... It can't have been an accident that these drawings began in 1819, the year in which Turner first went to Venice, the place where the distinction between solid form and fugitive reflection is least clear-cut. It was already a commonplace to notice that everything solid – power, morality, stone, money – seemed to crumble and dissolve in the iridescent dankness of Venice. And just around this time Turner seems to have begun a momentous shift towards an art that would be a representation of vision, not a reproduction of the physical world.

Simon Schama
Turner, in Power of Art 2006

Locations

BRITAIN
Birmingham
Barber Institute of Fine Arts, University of Birmingham
The Sun Rising Through Vapour, 1809
Birmingham Museums and Art Gallery
The Pass of St. Gotthard, Switzerland, 1803–1804
Blackburn
Blackburn Museum and Art Gallery
The Falls of Terni, 1817
Bournemouth
Russell-Cotes Art Gallery and Museum
St. Michael's Mount, Cornwall, 1834
Bury
Bury Art Gallery and Museum
Calais Beach at Low Tide: Poissards Gathering Bait, 1830
Englefield Green
Royal Holloway and Bedford New College
Van Tromp Going About to Please His Masters – Ships a Sea Getting a Good Wetting, 1844

Glasgow
Kelvingrove Glasgow Art Gallery and Museum
Modern Italy – The Pifferari, 1838
Leicester
New Walk Museum and Art Gallery
Cilgerran Castle, 1798–1799
London
British Museum
Messieurs les voyageurs on their return from Italy (par la diligence) in a snow drift upon Mount Tarrar — 22nd of January 1829, 1829
Kenwood House, The Iveagh Bequest
The Iveagh Seapiece, or Coast Scene of Fisherman Hauling a Boat Ashore, 1803–1804
National Gallery
Calais Pier, with French Poissards Preparing for Sea: an English Packet Arriving, 1802
Sun Rising through Vapour; Fishermen Cleaning and Selling Fish, 1807
Dido Building Carthage (or The Rise of the Carthaginian Empire), 1815
Odysseus Deriding Polyphemus, 1829

The Parting of Hero and Leander – from the Greek Epyllion of Musaios, 1837
The Fighting "Temeraire" Tugged to her Last Berth to be Broken Up, 1838
Rain, Steam and Speed – The Great Western Railway, 1844
Sir John Soane's Museum
Admiral Van Tromp's Barge Entering the Texel in 1645, 1831
Tate Britain
Self-Portrait, c. 1798–1799
The Sun of Venice Going to Sea, 1843
Victoria and Albert Museum
Life-Boat and Manby Apparatus Going Off to a Stranded Vessel Making Signal (Blue Lights) of Distress, 1831
Venice, The Salute and the Doge's Palace, from Guidecca, 1840
Petworth
Petworth House
Echo and Narcissus, 1804
The Estuary of the Thames and Medway, 1808

Cockermouth Castle, 1810
Chichester Canal, 1829
The Lake, Petworth: sunset, fighting bucks, 1829

JAPAN
Tokyo
Tokyo Fuji Art Museum
Seascape with a Squall Coming Up, 1803
Helvoetsluys; – the City of Utrecht, 64, Going to Sea, 1832

USA
Baltimore
Walters Art Museum
Raby Castle, Residence of the Earl of Darlington, 1817–1818
Boston
Museum of Fine Arts
The Slave Ship – Slavers throwing overboard the Dead and Dying – Typhoon coming on, 1840
Harvard
Fogg Art Museum, Harvard University Art Museums
Rembrandt's Daughter, 1827

Indianapolis
Indianapolis Museum of Art
The Fifth Plague of Egypt, 1800
Venice: The Rialto, 1820–1821
East Cowes Castle, the Seat of J. Nash, Esq.; the Regatta Beating to Windward, 1828
Oberhofen, Lake Thun, 1848
New Haven
Paul Mellon Collection, Yale Center for British Art
View of Tivoli with the Temple of the Sibyl and the Cascades, 1796
North-East View of Grantham Church, Lincolnshire, 1797
Lake Geneva and Mont Blanc, 1802–1805
The "Victory" Returning from Trafalgar, 1806
Lake Avernus: Aeneas and the Cumaean Sibyl, 1814–1815
Mount Vesuvius in Eruption, 1817
Dort, or Dordrecht, The Packet-Boat Dort from Rotterdam Becalmed, 1817–1818
Staffa, Fingal's Cave, 1832

Philadelphia
Philadelphia Museum of Art
The Burning of the Houses of Lords and Commons, 16th October, 1834, 1834
Washington
National Gallery of Art
The Dogana and Santa Maria della Salute, Venice, 1843

PRIVATE COLLECTIONS
The Unpaid Bill, or The Dentist Reproving his Son's Prodigality, 1808
Grand Junction Canal at Southall Mill Windmill and Lock, 1810
Landscape with Walton Bridges, c. 1845
Returning from the Ball (Santa Marta), 1846

Chronology

The following is a brief overview of the main events in the artist's life, plus the main historical events in his day (*in italic*).

1775
Turner is born on 23 April in London, son of William Turner, a hairdresser, and Mary Marshall.
Jane Austen is born.

1775–1783
American War of Independence.

1778
John Singleton Copley paints Watson and the Shark.

1789
At the age of only fourteen Turner is admitted to the Royal Academy Schools (–1793), where he studies under the direction of Thomas Malton the Younger.
Storming of the Bastille: start of the French Revolution. William Blake published Songs of Innocence and Experience.

1790
One of Turner's watercolors, *View of the Archbishop's Palace in Lambeth*, is accepted for the annual exhibition of the Royal Academy.

1792
Tom Paine publishes The Rights of Man.

1793
Turner is commended by the Society of Arts; journey to Kent and Sussex; becomes friends with Thomas Girtin.
War between France and Britain.

1795
Visits Wales and the Isle of Wight.

1796
Exhibits his first oil painting, *Fishermen at Sea*, at the Royal Academy.

1798
William Wordsworth and Samuel Taylor Coleridge publish the Lyrical Ballads, *the manifesto of the Romantic movement.*

1799
Elected an Associate Member of the Royal Academy.

1800
With the Act of Union the English parliament abolishes the parliament in Dublin and unites Ireland with Great Britain.

1801
Journey to Scotland, the Lake District, and Chester.

1802
Elected a Full Member of the Royal Academy; makes an extended journey to France and Switzerland and crosses the Alps; visits the Louvre in Paris, where he is impressed by the works of Titian and Nicolas Poussin.
Peace of Amiens between France and Britain.

1804
His mother dies after spending several years in Bethlehem Hospital in London. He opens his own gallery at 64 Harley Street in London.
Napoleon become Emperor of France.

1805
War between Britain and Napoleonic France. Battle of Trafalgar: Nelson is victorious over the French fleet.

1806
Begins to exhibit his works at the British Institution.

1807
Publishes the first volume of his *Liber Studiorum* and is appointed Professor for Perspective at the Royal Academy.
The Slave Trade Act abolishes the slave trade in the British Empire.

1809
Exhibits *Snow Storm, Hannibal and his Army Crossing the Alps* at the Royal Academy, accompanied by his own verses from his epic poem *Fallacies of Hope*.

1813
David Cox published Treatise on Landscape Painting and Effect in Water-colours.

1814
Participates in the founding of an artists' association known as the "Artists' General Benevolent Institution."

1815
Exhibits *Dido Building Carthage* at the Royal Academy. He refuses a large amount of money for the picture and decides to donate it to the National Gallery on the understanding that it is hung between two compositions by Claude Lorrain, *A Seaport with the Embarkation of the Queen of Sheba* (1648) and *Landscape with the Marriage of Isaac and Rebecca* (1648). *Wellington defeats Napoleon at Waterloo.*

1817
Journey to Belgium, along the Rhine Valley and to Holland, where he studies the works of Rembrandt.

1818
Journey to Scotland to illustrate the works of Sir Walter Scott. *Caspar David Friedrich paints* Chalk Cliffs on Rügen.

1819
First journey to Italy: Turner meets Antonio Canova in Rome and is elected an honorary member of the Accademia di San Luca. Meets members of the Nazarenes. *Peterloo Massacre in Manchester.*

1821
Visits Paris and northern France.

1824
Opening of the National Gallery in London. Death of Lord Byron in Greece.

1825
First railroad line, between Stockton and Darlington.

1827
First visit to Petworth, as the guest of Lord Egremont.

1828
Second Italian journey; during his visit to Rome he exhibits his works in the Palazzo Trulli.

1829
Death of his father. Meets Sophia Caroline Booth, and travels to Normandy and Paris, where he probably meets Eugène Delacroix. *John Constable is accepted as a member of the Royal Academy. First steam locomotive produced by George Stephenson.*

1830
Illustrates Samuel Rogers' book *Italy.*

1831
Travels to Scotland to illustrate works by Sir Walter Scott.

1833
First volume of his *Annual Tour* published; visits Germany, Austria, and Venice.

1834
Witnesses the fire at the Palace of Westminster and produces two oil paintings.

1835
Travels to Denmark, Germany, and Bohemia. *The Barbizon School is formed in France.*

1837
Resigns as Professor for Perspective at the Royal Academy. *Death of John Constable. Victoria becomes queen.*

1839
Exhibits *The Fighting "Temeraire" Tugged to her Last Berth to be Broken Up* at the Royal Academy. *Daguerre announces the invention of photography at the Académie des Sciences in Paris.*

1840
First meeting with John Ruskin.

1843
Ruskin published the first volume of *Modern Painters.*

1844
Exhibits *Rain, Steam and Speed – The Great Western Railway* at the Royal Academy.

1845
Great Irish potato famine.

1850
Exhibits his works for the last time in the Royal Academy. Executes his last oil paintings, although he continues to paint watercolors.

1851
Turner dies on 19 December at the age of seventy-six in his villa in Chelsea; he is buried on 30 December in the crypt of St. Paul's Cathedral. *The Great Exhibition is held in Crystal Palace in London. Herman Melville publishes Moby Dick.*

Literature

A. J. Finberg, *The Life of J.M.W. Turner*, Oxford 1939 (revised 1962)

Graham Reynolds, *Turner*, London 1969

William Gaunt, *Turner*, London 1971

John Gage, *Turner: Rain, Steam and Speed*, London 1972

Andrew Wilton, *The Life and Works of J.M.W Turner*, London 1979

Andrew Wilton, *Turner Abroad: France, Italy, Germany, Switzerland*, London 1982

Martin Butlin, Evelyn Joll, *The Paintings of J.M.W. Turner*, New Haven and London 1984

Lindsay Stainton, *Turner's Venice*, London 1985

John Gage, *J.M.W Turner: A Wonderful Range of Mind*, New Haven and London 1987

Eric Shanes, *Turner's Human Landscape*, London 1990

David Hill, *Turner on the Thames*, New Haven and London 1993

Andrew Bailey, *Standing in the Sun: A Life of J.M.W. Turner*, London 1997

James Hamilton, *Turner: A Life*, London 1997

Luke Herrmann, *J.M.W. Turner: Watercolors, Drawings and Paintings*, Oxford 2000

Sam Smiles, *J.M.W Turner*, London 2000

Evelyn Joll, Martin Butlin, and Luke Herrmann, *The Oxford Companion to Turner*, Oxford 2001

David Blayney Brown, *Turner in the Tate Collection*, London 2002

James Hamilton, *Turner's Britain*, London and New York 2003

Katharine Lochnan and others, *Turner Whistler Monet*, exh. cat., London 2004

Peter Ackroyd, *J.M.W. Turner*, London 2005

Olivier Meslay, *J.M.W. Turner: The Man Who Set Painting on Fire*, London and New York 2005

Stanley Warburton, *Discovering Turner's Lakeland*, Lytham St. Annes 2008

Inés Richter-Musso and Ortrud, *Turner and the Elements*, exh. cat. Hamburg 2011

Photo credits